VIEWS OF PHILADELPHIA 1800 · 1960 · 1982

A COMPARATIVE RECORD

Birch's Views of Philadelphia

A Reduced Facsimile of *The City of Philadelphia . . . as it appeared in the Year 1800*

With Photographs of the Sites in 1960 & 1982 by S. Robert Teitelman

THE FREE LIBRARY OF PHILADELPHIA · 1982

A Publication in Celebration of
the Three Hundredth Anniversary of the Founding of Philadelphia
Made Possible by Grants from

THE ATLANTIC RICHFIELD FOUNDATION

THE MCLEAN CONTRIBUTIONSHIP

C. G. SLOAN AND COMPANY, INC.

SMITHKLINE BECKMAN CORPORATION

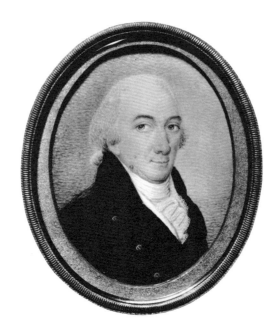

WILLIAM RUSSELL BIRCH
(1755–1834)
Self Portrait. Oil on ivory.
Miniature, 2⁵/₈ x 2″.
Inscription on back: "Louisa S. Birch from
her father November 24, [18]18."
The Walters Art Gallery, Baltimore.

AN INTRODUCTION

VIBRANT with trade and commerce, handsome with marble and brick, Philadelphia in 1800 was perceived by William Russell Birch as having "been raised, as it were, by magic power, to the eminence of an opulent city" in a little more than a century. Birch, an accomplished English enamel painter and engraver, came to the city, then the nation's capital, in 1794. Inspired by the prosperity and beauty of his new surroundings he conceived a series of engravings which would "give the most general idea of the town," its public and private buildings, busy street life, port and shipyards. The resulting twenty-seven views were published under the title *The City of Philadelphia . . . As It Appeared in the Year 1800*. Acclaimed a masterpiece of American color-plate publishing, the book as an eighteenth-century pictorial record of an American city is incomparable.

Describing the production of his book Birch wrote, "I superintended it, chose the subjects, instructing my Son [Thomas] in the Drawings, and our Friend Mr. [Samuel] Seymour in the Engravings." The exact role of each, however, is open to question, for all the pictorial plates except one indicate they were drawn and engraved by "W. Birch & Son." William Barker engraved the title page and the plan of the city, and Richard Folwell was the printer of the book. Young Birch, who served his apprenticeship in this project, later became one of America's pioneer landscape and marine painters.

The engravings are dated 1798, 1799, or 1800, except for three which are undated. Some and probably all were sold separately.

Although Robert Campbell is named as publisher on eight of them, and as seller, with "W. Birch & Son" as publisher, on fourteen, his connection with the project seems to have ended before the publication of the book on December 31, 1800. William Birch alone is named on the title page as publisher.

"The price of the Work, in boards, [was] 28 Dollars; bound, 31 dollars; if coloured, in boards, 41½ Dollars; bound, 44½ Dollars." Subscribers, of whom there were 156 listed at the end of the book, included Mathew Carey, publisher, Thomas Jefferson, Vice-President of the United States, Benjamin Henry Latrobe, architect and engineer, Thomas Mifflin, former Governor of Pennsylvania, Richard Varick, Mayor of New York, and British and Spanish diplomats. Selected views, with minor changes, were copied and used as illustrations in volumes published in London and Stockholm. Some thirty years after his book was issued Birch wrote, "there is at this time scarsely one sett of the work in Philadelphia that was not sent to Europe."

A full account of the various editions of Birch's book, including collations and a table of the states of individual views, is to be found in Martin P. Snyder's definitive articles, "William Birch: His Philadelphia Views" published in *The Pennsylvania Magazine of History and Biography*, Volume 73 (1949), pages 271–315, and "Birch's Philadelphia Views: New Discoveries," in the same journal, Volume 88 (1964), pages 164–173, to which we are obliged for many of the facts given here about Birch and his book.

Birch's folio memorializes Philadelphia at the end of the eigh-

teenth century when its development was at a peak. This book celebrates the 300th anniversary of the founding of the city and three decades of revitalization during which its development has moved toward another peak.

Seeds of revitalization were sown after World War II. In an exhibition held in 1947 Edmund N. Bacon, Executive Director of the City Planning Commission, unveiled his innovative ideas for a better Philadelphia. The next year the Commission certified the rehabilitation of the area bounded by Front, Walnut, Eighth and Lombard streets, now known as Society Hill. With a reformist city government elected in 1951 and the adoption of a Home Rule City Charter giving the mayor greater power, the way was cleared for imaginative redevelopment of the city. That year the city turned over to the National Park Service the custody and operation of the Independence Hall group of buildings, which became the nucleus of Independence National Historical Park.

By 1960 most of the Park and all of Independence Mall had been cleared except for historic buildings (Plates 17 and 7), and restoration of those was in progress. The American Philosophical Society had completed its new library within the Park, the Fifth Street façade being a reconstruction of Library Hall (Plate 19). In Society Hill restoration of residences had begun, and, with merchants relocated in the new Food Distribution Center in South Philadelphia, the Dock Street markets had been removed. West of City Hall the old Broad Street Station was down, as was the Chinese Wall that carried the tracks, and on the site of the Wall the first three towers of the Penn Center office complex were up (Plate 28). Further to the west the Schuylkill Expressway had recently been opened.

In 1960 a comprehensive twenty-year plan of great significance was presented by the City Planning Commission covering industry, commerce, recreation and community facilities, residences and transportation throughout the city. The plan for Center City, among its other projects, proposed in detail the Market Street East redevelopment, the commuter connection tunnel with a new Filbert Street Station, the Chestnut Street landscaped shopping mall, recreational facilities at Penn's Landing, including a marina, and the Vine Street Crosstown Expressway.

Not all of the twenty-year plan has been achieved, nor is all that has been achieved shown in the photographs reproduced here, as they are limited to the twenty-seven sites pictured by Birch.

Important achievements evident in the 1982 photographs include: landscaping of Independence National Historical Park (Plate 17), landscaping of Independence Mall (by then part of the Park) and the building of the new Mint (Plate 7), vista clearing for Christ Church (Plate 15), the rebuilding of City Tavern (Plate 27), I. M. Pei's Society Hill Towers (Plate 2), restored residences in Society Hill (Plate 18), restoration and redevelopment in New Market (Plate 16), Market Street East, Gallery I (Plate 12), and progress on the Center City Commuter Connection Tunnel (Plate 28).

Important achievements not shown in the photographs include, among others: Penn's Landing recreational facilities, new Packer Avenue and Tioga marine terminals, West Market Street office and hotel buildings, University City Science Center, expanded academic facilities, Veterans Stadium and the Spectrum, Vine Street Expressway, Interstate Highway 95, and modernization of Philadelphia International Airport.

One of the finest copies known of Birch's *City of Philadelphia . . . in the Year 1800*, the Sidney E. Martin-Arthur J. Sussell copy, was purchased at auction by the Free Library in 1959. Prompted by that acquisition the Library in 1960 held an exhibition of the book and separate copies of the views, together with photographs of the same sites as they appeared that year, and related material. In August of 1982, to celebrate the 300th anniversary of the founding of Philadelphia, the Library remounted the exhibition, omitting the related material and adding views of the sites taken the same year.

This book, essentially a record of the 1982 exhibition, is a facsimile of the Library's copy of Birch, reduced by one third, with a modern map, photographs, notes and site plans inserted. On the plans principal buildings pictured by Birch which are still standing are printed in black, and those demolished in gray. Arrows indicate Birch's vantage points and lines of sight. In most instances the photographs were taken from his vantage points, but at times, to show significant changes adjacent to the sites, or to accomplish with the camera what Birch had through artistic license, or to avoid obstructions, the vistas have been broadened or the vantage points varied. All of the sites and principal buildings shown in the views, except the first and last, are located on a 1982 map printed on the page facing Birch's 1800 plan of the city. A list of seven readily available books on Philadelphia and references to illustrations related to Birch's views which are found in them are given in an appendix.

In writing the notes we have turned to John F. Watson's *Annals of Philadelphia* (Philadelphia, Edwin S. Stuart, 1905), first published in 1830 and expanded by Willis P. Hazard in 1879, to J. Thomas Scharf and Thompson Westcott's *History of Philadelphia, 1609–1884* (Philadelphia, L. H. Everts, 1884), to Margaret B. Tinkcom's "The New Market in Second Street," *The Pennsylvania Magazine of History and Biography*, Volume 82 (1958), pages 379–396, and to Negley K. Teeters' *The Cradle of the Penitentiary: The Walnut Street Jail at Philadelphia, 1773–1835* (Philadelphia? 1955). Among the books listed in detail in the appendix we have relied on George B. Tatum's *Penn's Great Town*, especially for the dates of the completion and demolition of many of the buildings pictured by Birch, and on *Historic Philadelphia* and Edwin Wolf, 2nd's, *Philadelphia: Portrait of an American City*. The authors of those works, from Watson to Wolf, have written about Philadelphia with pride and affection, with grace and learning. Without their help our task would have been increased immeasurably.

We have profited from conversations with Penelope H. Batcheler and David Dutcher of Independence National Historical Park, Edward W. Duffy of the Philadelphia City Planning Commission, Constance Greiff of Princeton, New Jersey, Alix Kadosh of the Pennsylvania Hospital, James E. Panyard of the Greater Philadelphia Partnership, John T. Sexton of the Delaware River Port Authority, and Patricia Siemiontkowski of the Philadelphia Historical Commission, and are obliged to Lilian M. C. Randall and Jean Carroon of the Walters Art Gallery who supplied the photograph of the miniature of William Birch.

The modern general map and the site plans accompanying the views are the work of Will McLean, graphic artist. For the excellent design of the book and the high quality of its reproductions we are indebted to C. Freeman Keith and William J. Glick and their colleagues of The Stinehour Press and The Meriden Gravure Company.

Finally, we wish to express our gratitude to Keith Doms, the Director of the Free Library of Philadelphia, to the Board of Trustees of the Library, and to the officers, directors and trustees of the Atlantic Richfield Foundation, the McLean Contributionship, the SmithKline Beckman Corporation, and C. G. Sloan and Company. Their encouragement and generous support have made possible the publication of this comparative record as Philadelphia enters its fourth century, enriched by its heritage.

S. ROBERT TEITELMAN

1 September 1982 HOWELL J. HEANEY

The

CITY OF PHILADELPHIA,

in the State of Pennsylvania

North America;

as it appeared in the Year 1800

consisting of TWENTY EIGHT Plates

Drawn and Engraved by W. BIRCH & SON.

Published by W. Birch, Springland Cot, near Neshaminy Bridge on the Bristol Road; Pennsylvania. Dec.r 31.t 1800.

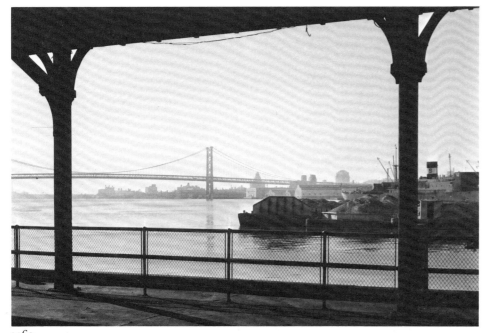

1960

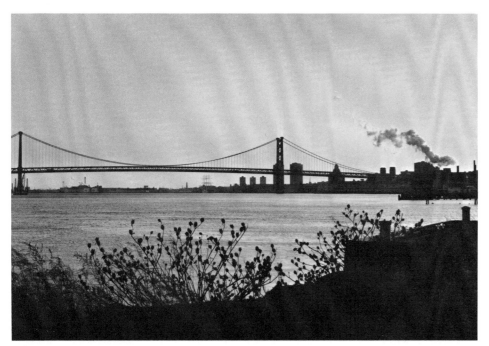

1982

PLATE 2

ENGRAVING

Birch wrote in his introduction: "the frontispiece represents, with the city at large, a busy preparation for commerce." Philadelphia in 1800 was the commercial and cultural center of the United States, and had for the past ten years been its capital. The great elm, commonly believed to mark the site of Penn's treaty with the Indians, was blown down in 1810. Kensington and Southwark (shown in Plate 29) were the shipbuilding areas of the city.

PHOTOGRAPHS

Although no shipping appears in the 1982 view, Philadelphia handles more international waterborne commerce than any other east coast port. Busy modern terminals lie to the north and south of this stretch of the river. A foreign trade zone has been established and Philadelphia today is an international city. Prominent additions to the skyline since 1960 are, from left to right, the Southwark Public Housing buildings and the Society Hill Towers.

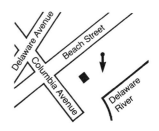

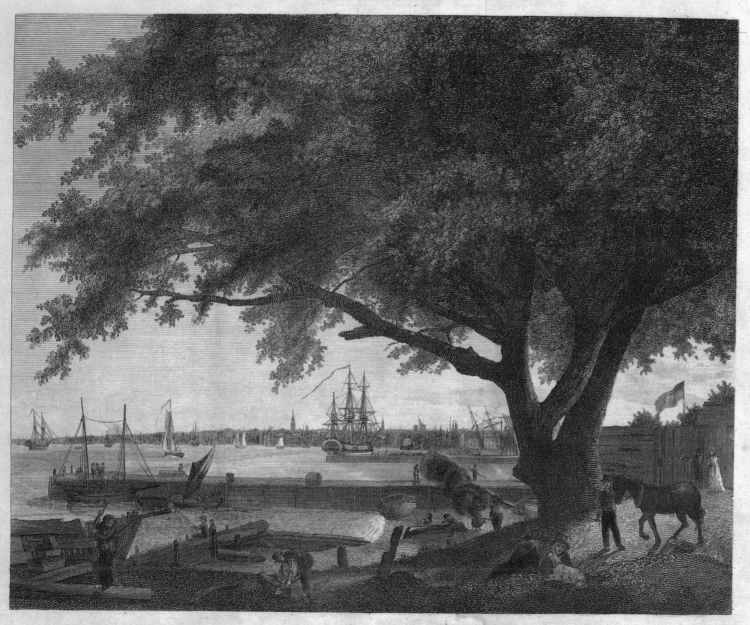

The City & Port of PHILADELPHIA *, on the River Delaware from Kensington.*

Published as the Act directs by W.Birch, Springland Cot, near Bristol. 1800.

PHILADELPHIA.

The ground on which it ſtands, was leſs than a century ago, in a ſtate of wild nature; co-vered with wood, and inhabited by Indians. It has in this ſhort time, been raiſed, as it were, by magic power, to the eminence of an opulent city, famous for its trade and commerce, crouded in its port, with veſſels of its own producing, and viſited by others from all parts of the world. Its ſituation on the bank of the Delaware, lies about 40 degrees north from the equator, and about 75 degrees weſt from London, on the weſt ſide of the river, about 40 leagues from the ſea. Its plan was laid out by William Penn, and was confirmed by charter, on the 25th of October, 1701. This Work will ſtand as a memorial of its progreſs for the firſt century; the buildings, of any conſequence, are generally included, and the ſtreet-ſcenes all accurate as they now ſtand; the choice of ſubjects are thoſe that give the moſt general idea of the town; the ſcenery is confined within the limits of the city, excepting the firſt and laſt views: the frontiſpiece repreſents, with the city at large, a buſy preparation for com-merce, and the laſt plate, with the Swediſh church, the exertion of naval architecture to protect it; each ſubject terminating at the oppoſite extremities of the ſuburbs, on the bank of the river.

PLAN OF 1982

Locating Sites and Principal Buildings Appearing in Birch's Views of 1800

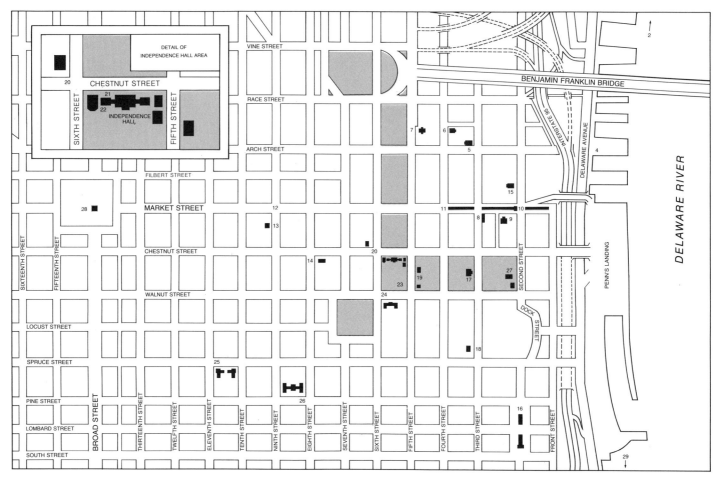

Key numbers correspond to Birch's plate numbers. He counted the engraved title-page as Plate 1 and the Plan of the City as Plate 3.

2. City and Port from the Treaty Elm*
4. Arch Street Ferry
5. *Second Presbyterian Church***
6. *New Lutheran Church*
7. *Old Lutheran Church*
8. Third and Market Streets (*Cooke's Folly*)
9. *First Presbyterian Church*

10. *High Street Market*
11. *Country Market*
12. High Street from Ninth
13. *House Intended for the President*
14. *Unfinished House* (*Morris House*)
15. Christ Church and *Town Hall*
16. New Market
17. Bank of the United States
18. Third Street from Spruce (*Bingham House*)
19. Library† and *Surgeons' Hall*

20. Congress Hall and *New Theatre*
21. State House (now Independence Hall)
22. Back of the State House
23. State House Garden
24. *Gaol*
25. *Alms House*
26. Pennsylvania Hospital
27. *Bank of Pennsylvania* and tne City Tavern†
28. *Water Works*
29. Old Swedes' Church (Gloria Dei)‡

* A mile and four tenths north of Market Street.
** Names in italics are of buildings no longer standing.

† Rebuilt.

‡ A mile south of Market Street.

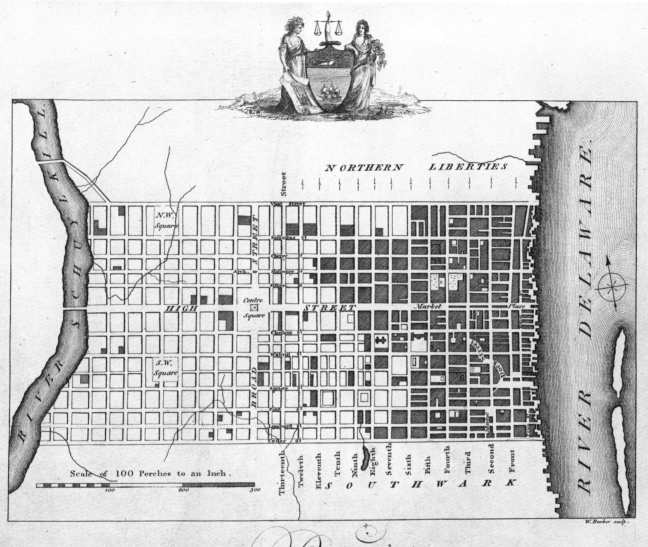

NORTHERN LIBERTIES

RIVER SCHUYLKILL

RIVER DELAWARE.

N.W. Square

Vine Street

Sassafras St

Cherry

Mulberry St

Arch. or

Filbert

HIGH STREET

Centre Square

Market Place

Chesnut St

Walnut St

S.W. Square

Spruce St

Pine St

Lombard St

Cedar St

BROAD STREET

Scale of 100 Perches to an Inch.

100 200 300

Thirteenth Twelfth Eleventh Tenth Ninth Eighth Seventh Sixth Fifth Fourth Third Second Front

SOUTHWARK

W. Barber sculp.

Plan

OF THE

City of Philadelphia

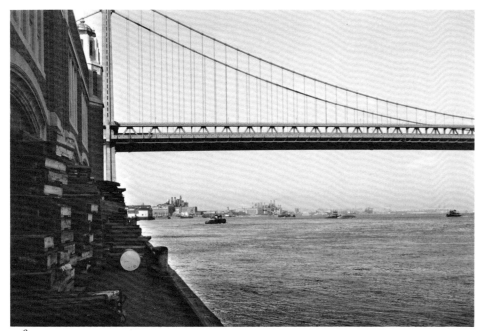

1960

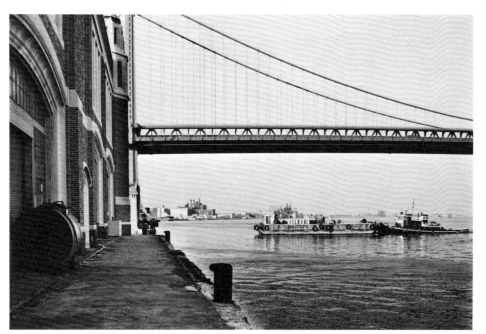

1982

PLATE 4

ENGRAVING

At the foot of Arch Street was a terminal for the Cooper family's ferry. This and other ferries were the transportation links with southern New Jersey villages and farms which provided much of the produce sold in the markets along High Street. From this point in 1790 John Fitch's steam boat began carrying passengers regularly to Burlington, Bristol, Bordentown and Trenton. Fitch invented the first boat successfully propelled by steam.

PHOTOGRAPHS

The views were taken from the end of Municipal Pier 5. Made obsolete by more modern facilities at the Packer and Tioga marine terminals, the pier is to be converted into residential condominiums. The Delaware River Bridge, now known as the Benjamin Franklin Bridge, was opened in July 1926. A commuter rail line added to it in 1936 was replaced in 1969 by a model automated rapid transit system which was extended to outlying New Jersey communities.

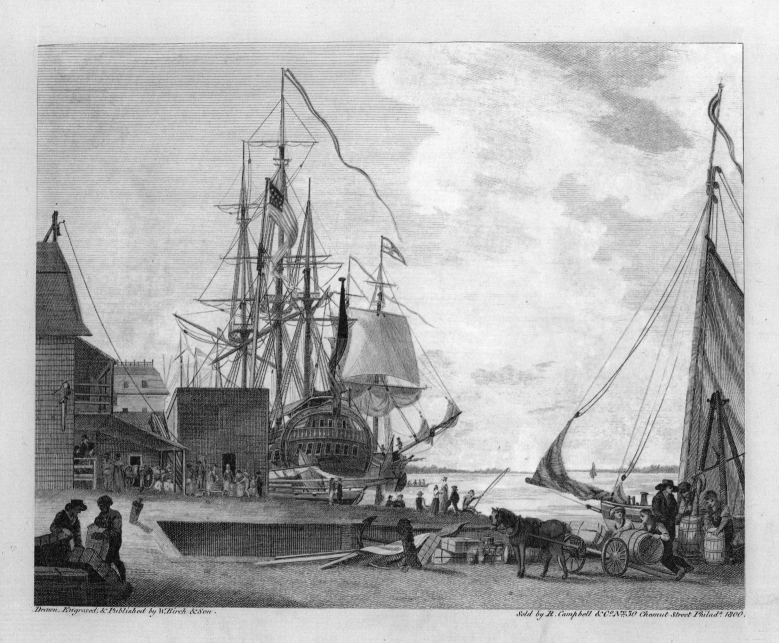

Drawn, Engraved, & Published by W. Birch & Son. Sold by R. Campbell & Co. No. 30 Chesnut Street Philad.a 1800.

ARCH STREET FERRY, PHILADELPHIA.

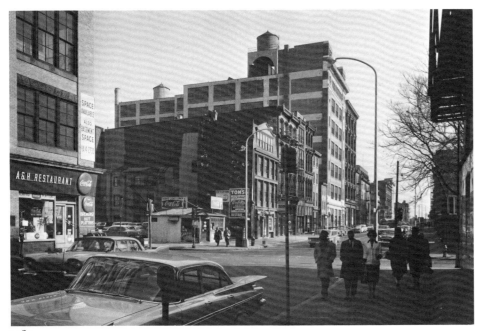

1960

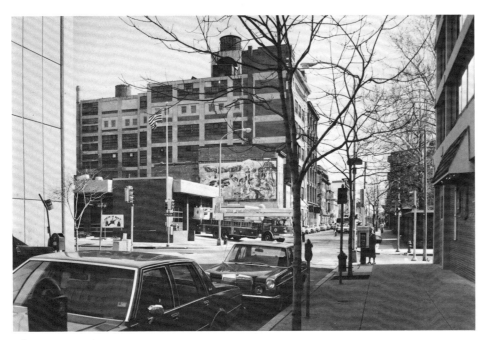

1982

PLATE 5

ENGRAVING

The Second Presbyterian Church was built 1750–1753 and demolished in 1837–1838. A charity school was opened by the congregation about 1794, one of a number of such schools organized at that time. They were the forerunners of public elementary schools which were established for the poor in 1818, and for all children in 1836.

PHOTOGRAPHS

Commercial buildings near the northeast corner of Fourth and Arch streets have been replaced by a firehouse erected in 1968 for Engine 8 and Ladder 2 of the Philadelphia Fire Department. Engine 8 proudly traces its roots back to the Union Fire Company, the first in colonial America, founded by Benjamin Franklin and his friends in 1736. On the northwest corner is the United States Mint, completed in 1969, and on the southwest corner a Holiday Inn.

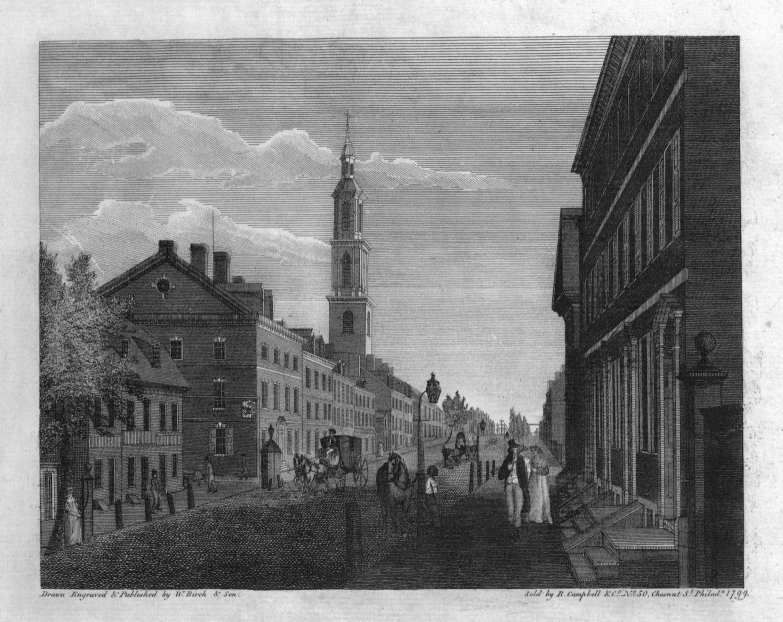

Drawn Engraved & Published by W. Birch & Son. Sold by R. Campbell & Co. N.º 30, Chesnut S.ᵗ Philad.ᵃ 1799.

ARCH STREET, with the Second Presbyterian CHURCH.

PHILADELPHIA.

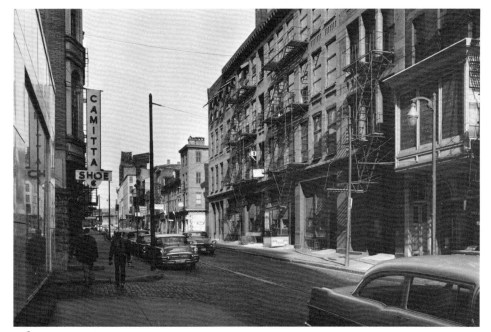

1960

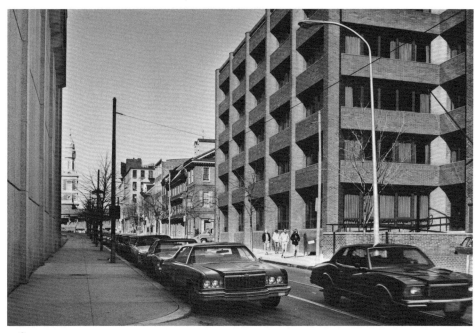

1982

PLATE 6

The New Lutheran Church (Zion) was built 1766–1769 from designs of Robert Smith. It burned December 26, 1794, was rebuilt 1795–1796 and demolished in 1869. The Congressional memorial service for George Washington was conducted here on December 26, 1799, by Bishop William White. General Henry Lee delivered the funeral oration. During the years Philadelphia was the nation's capital delegations of Indians, who had come to settle their affairs with the government, were often seen being shown around the city.

PHOTOGRAPHS

Commercial buildings appearing in the 1960 view have been replaced, on the left by the United States Mint completed in 1969, and on the right, below Cherry Street, by the Teamsters' building completed in 1974. A group of buildings above Cherry Street has been restored to appear as it did in the engraving. The tower of St. Augustine's church is seen in the distance.

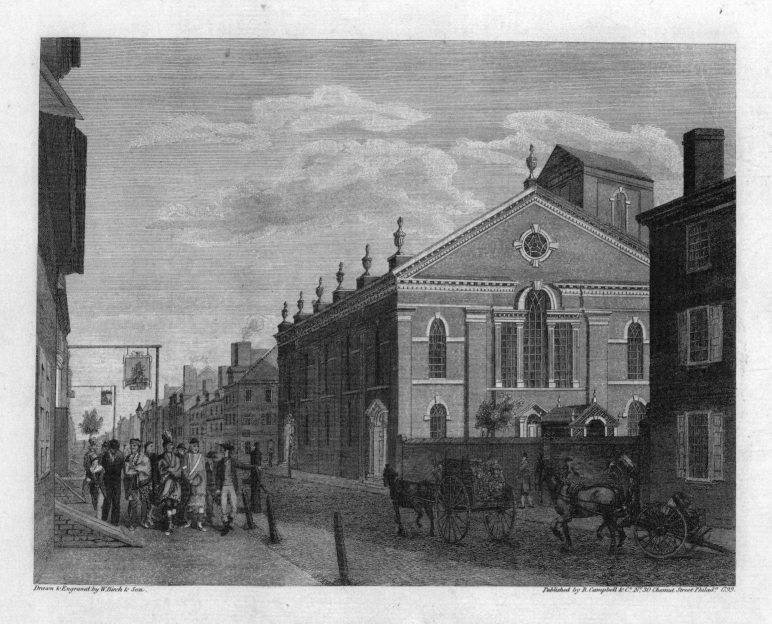

Drawn & Engraved by W.Birch & Son. Published by R.Campbell & C⁰. N⁰.30 Chesnut Street Philad⁰. 1799.

New *LUTHERAN CHURCH*, in *Fourth Street* PHILADELPHIA.

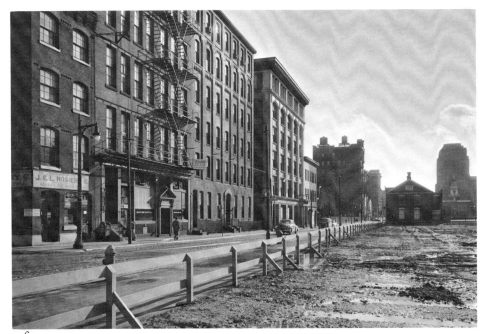

1960

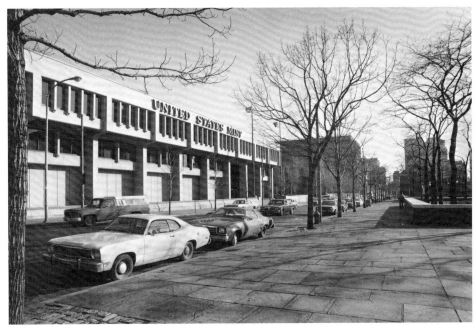

1982

PLATE 7

ENGRAVING

The Old Lutheran Church (St. Michael's) was built 1743–1748 and demolished in 1872. Enlarged by the increase of German immigration, the congregation built the "New Lutheran Church" (Zion) in 1769 (Plate 6), and used both buildings for the next one hundred years.

PHOTOGRAPHS

The 1960 view shows a portion of the area cleared by the Commonwealth of Pennsylvania for Independence Mall. After 1960 the Free Quaker Meeting House at the southwest corner of Fifth and Arch streets (right middle ground) was moved to the west so that Fifth Street could be widened. Commercial buildings on the east side of the street were demolished and on that site the United States Mint was built 1965–1969. Between 1976 and 1980 the Commonwealth turned over the Mall to the National Park Service.

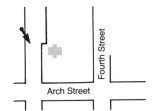

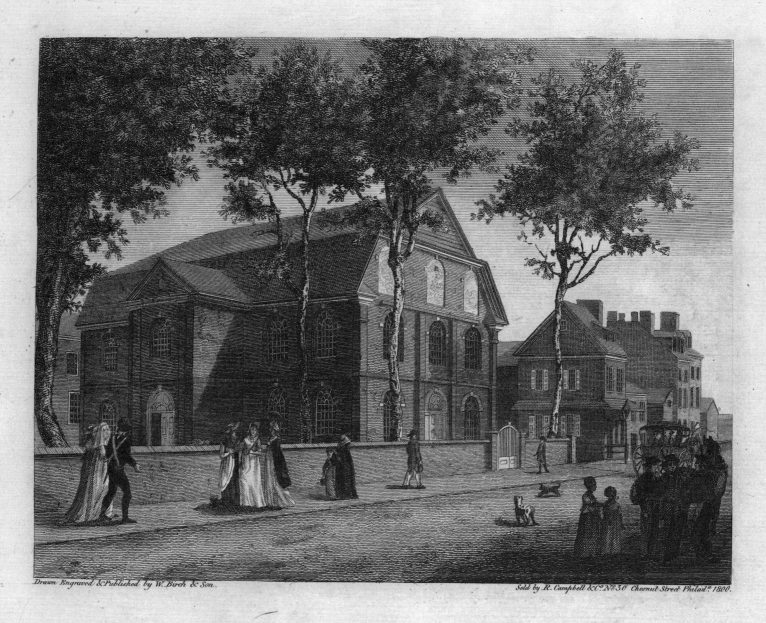

Drawn Engraved & Published by W. Birch & Son. Sold by R. Campbell &Cᵒ Nᵒ 30 Chesnut Street Philadᵃ 1800.

Old *LUTHERAN CHURCH*, *in Fifth Street* PHILADELPHIA.

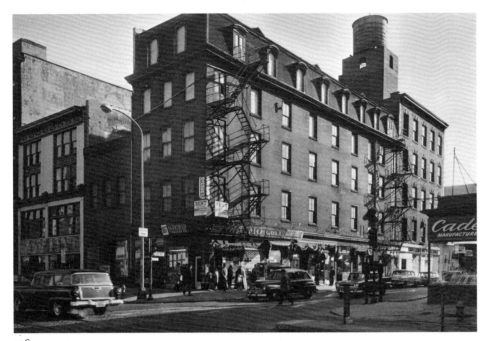

1960

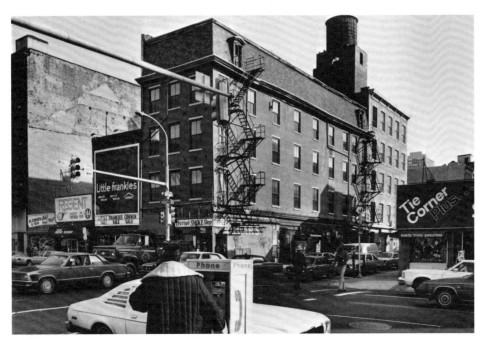

1982

PLATE 8

ENGRAVING

The building at the corner is "Cooke's Folly," built about 1792 by Joseph Cooke, goldsmith and jeweler. Splendid shops were on the ground floor and dwellings above. "Too fine for the age, it gradually fell into decay," and was demolished about 1838.

PHOTOGRAPHS

The building now at the corner, never too fine for its age, appears headed for the same fate.

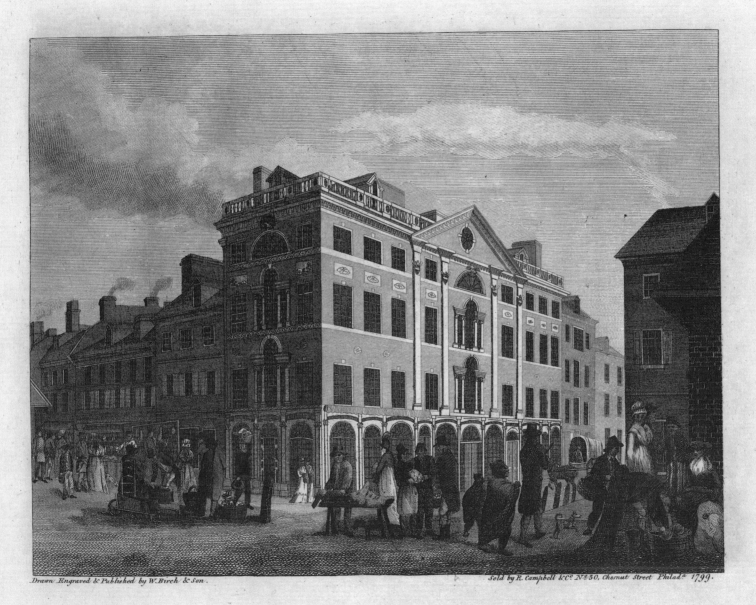

Drawn Engraved & Published by W. Birch & Son. Sold by R. Campbell & Cᵒ. Nᵒ 50, Chesnut Street Philadᵃ 1799.

South East CORNER of THIRD, and MARKET Streets.

PHILADELPHIA.

PLATE 9

ENGRAVING

The First Presbyterian Church was built 1793–1794 from designs of John Trumbull and demolished about 1822. As early as 1800 High Street was also called Market Street because of the sheds in the center. That name was made official by an ordinance of 1858, ironically just a year before the sheds were ordered removed.

PHOTOGRAPHS

The buildings at the left in the 1960 view are between Front and Second streets. They were replaced by a ramp, from Delaware Avenue over Interstate Highway 95, which can be seen in the background of the 1982 view.

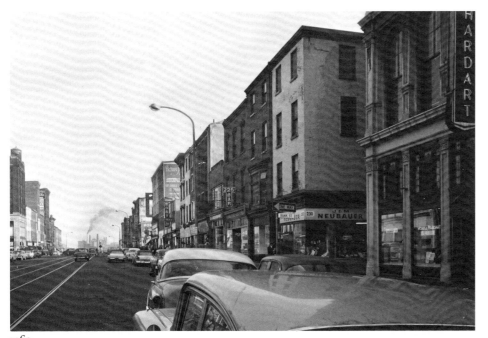

1960

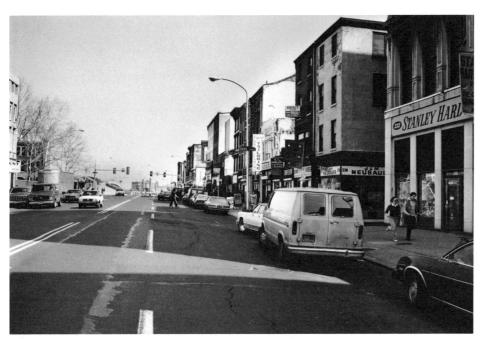

1982

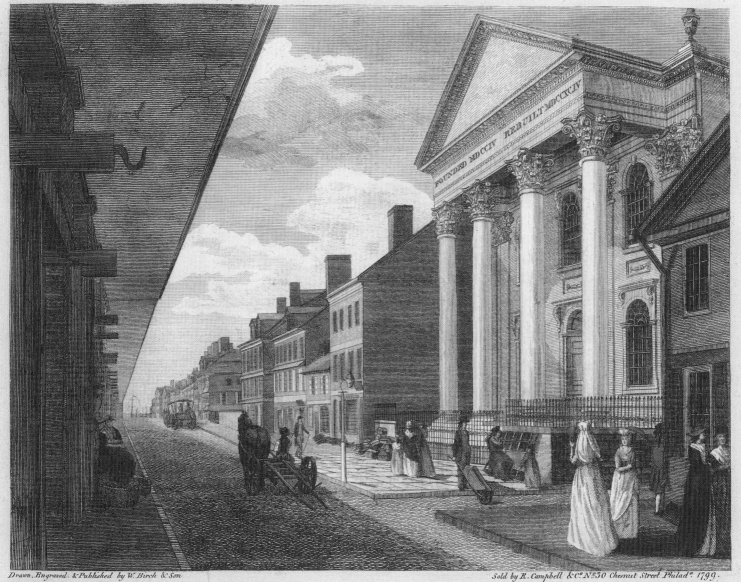

Drawn, Engraved, & Published by W. Birch & Son. Sold by R. Campbell & C°. N°. 30 Chesnut Street Philad°. 1799.

HIGH STREET, with the First Presbyterian CHURCH.

PHILADELPHIA.

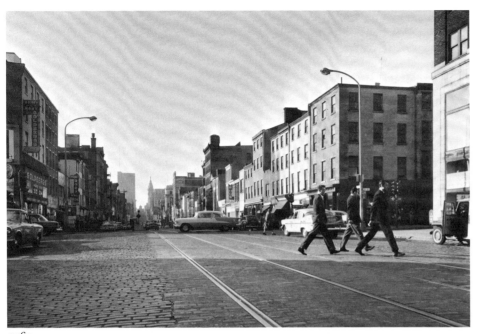

1960

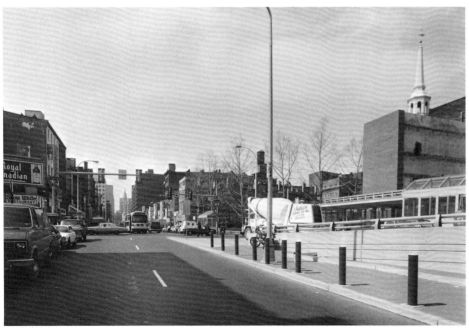

1982

PLATE 10

ENGRAVING

From inside this market shed between Front and Second streets Birch gives a vista extending to Fourth Street. A variety of wares, meats, and produce from the outlying farms in both Pennsylvania and New Jersey were sold in the markets, the last of which was demolished about 1860.

PHOTOGRAPHS

The buildings on the north side of Market Street between Front and Second were cleared to make way for a ramp from Delaware Avenue over Interstate Highway 95, and a group of buildings west of Second Street were cleared to provide a view of Christ Church.

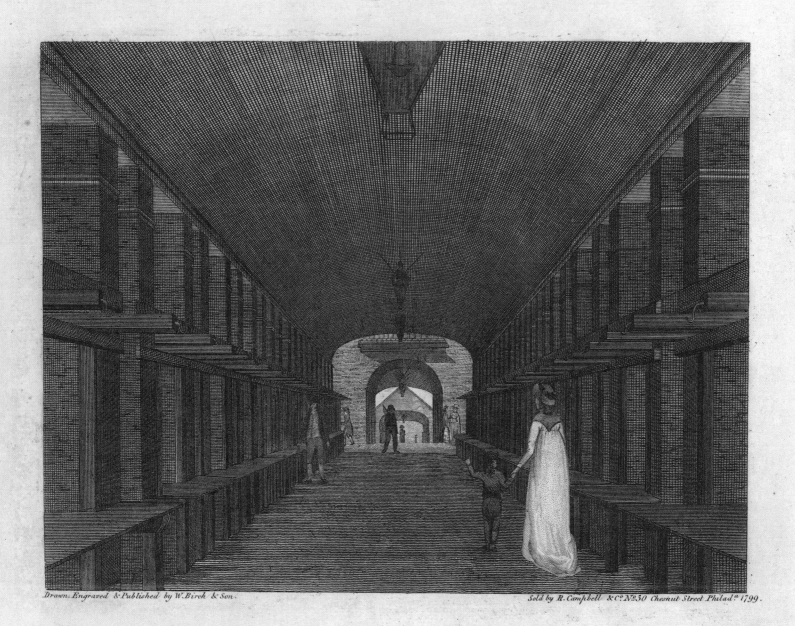

Drawn, Engraved & Published by W. Birch & Son.

Sold by R. Campbell & Cº. Nº 30 Chesnut Street Philadª 1799.

HIGH STREET MARKET, PHILADELPHIA.

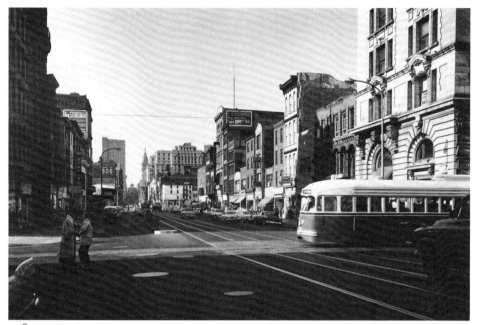

1960

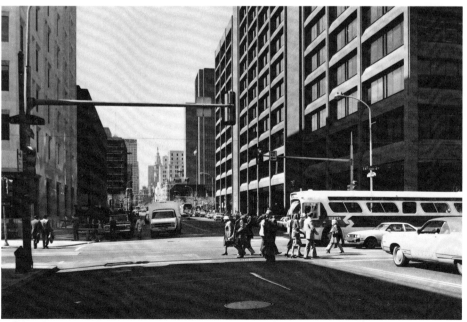

1982

PLATE 11

George Washington died at Mount Vernon on December 14, 1799. Twelve days later a memorial procession decreed by Congress assembled at the State House (Independence Hall) and proceeded to Zion Lutheran Church (Plate 6) for a service. The procession included a draped empty bier and an unmounted horse. Military organizations and the clergy preceded the bier; members of Congress, government officials and others followed it.

PHOTOGRAPHS

Buildings between Fourth and Fifth streets on Market were demolished about 1970. Thereafter the Philadelphia National Bank Plaza Building was erected on the north side, and the Continental Building and studios for Station KYW and Channel 3 TV on the south side.

Market Street

Fourth Street

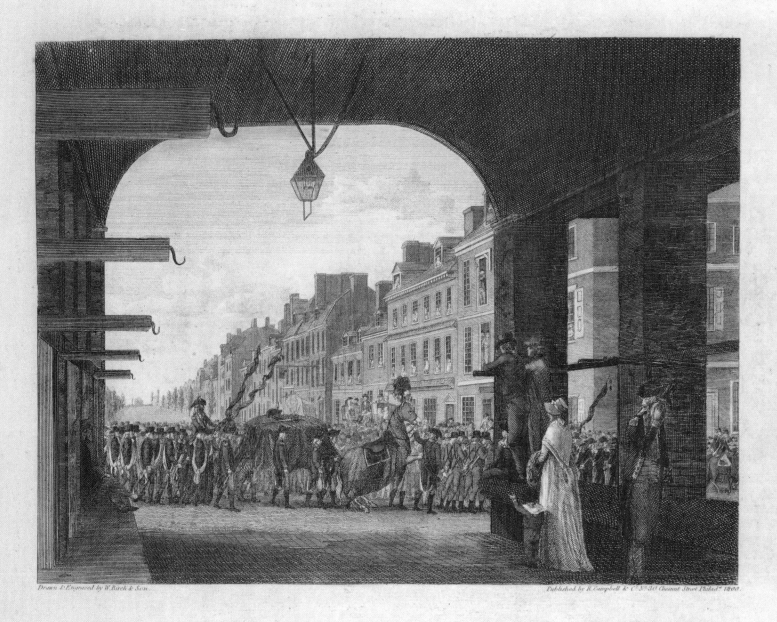

Drawn & Engraved by W. Birch & Son. Published by R. Campbell & C.º Nº 30 Chesnut Street Philadª 1800.

HIGH STREET, From the Country Market-place PHILADELPHIA.

with the procession in commemoration of the Death of GENERAL GEORGE WASHINGTON, December 26.ᵗʰ 1799.

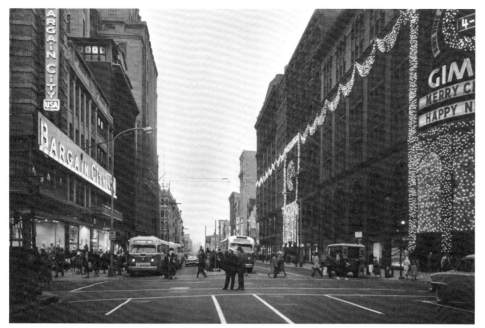

1959

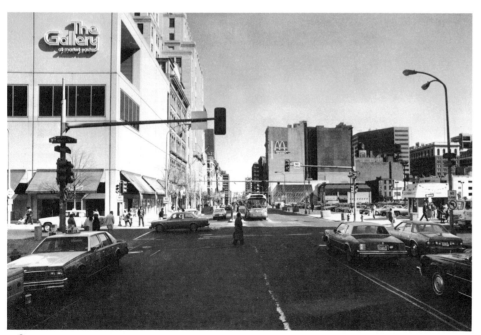

1982

PLATE 12

ENGRAVING

Tradition has it that the horsemen in the view are a detachment of the First City Troop. The Troop was organized in 1774 to defend the city from possible attack and is the oldest continuously active mounted military unit in the United States. In the distance are the market sheds between Fourth and Front streets.

PHOTOGRAPHS

With the completion of "The Gallery" in 1977 a center of department store business, long established at Eighth and Market streets, shifted a block west. This new complex comprises two major stores, Gimbels (relocated) and Strawbridge & Clothier, and 125 shops and restaurants. "Gallery II" on the north side of Market Street between Tenth and Twelfth is under construction. The area will be served by the new Center City Commuter Connection Tunnel, which will link existing rail lines from the north and west.

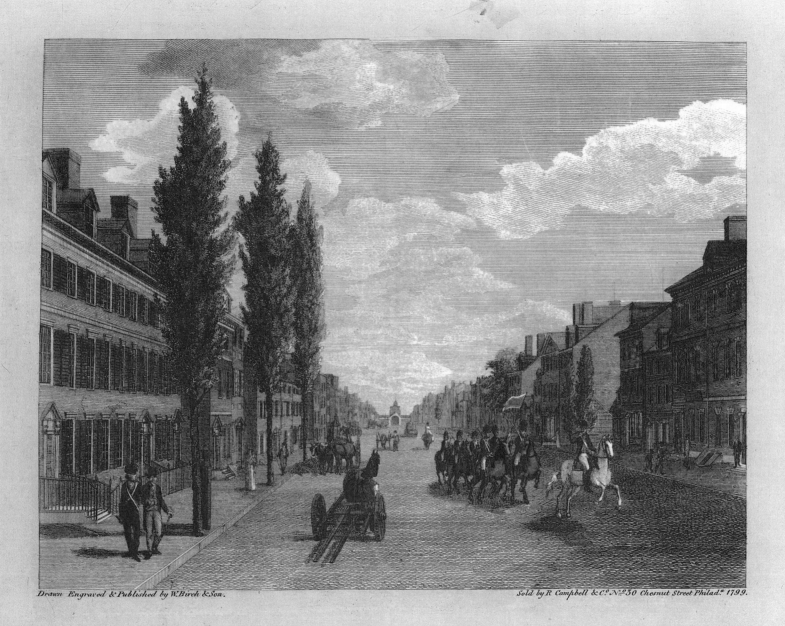

Drawn Engraved & Published by W. Birch & Son. Sold by R. Campbell & Cᵒ. Nᵒ. 30 Chesnut Street Philadᵃ. 1799.

HIGH STREET, *from Ninth Street.* PHILADELPHIA.

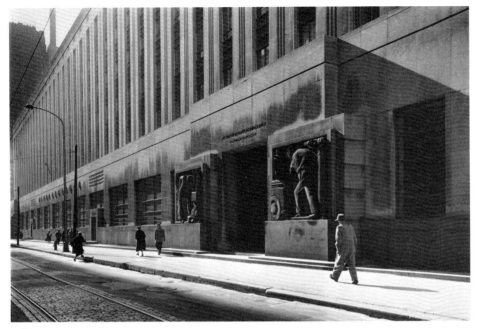

1960

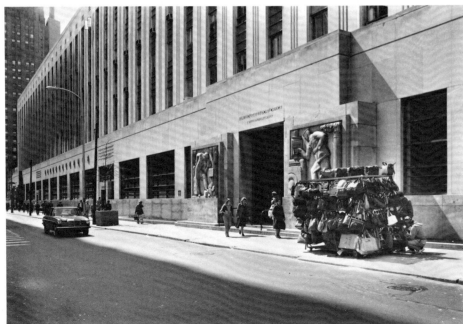

1982

PLATE 13

ENGRAVING

The Commonwealth of Pennsylvania started to build this mansion in 1792, while Washington was President. Long in construction, it was completed in 1797. John Adams, then President, declined to occupy it, renting instead the smaller house at 190 High Street (below Sixth) in which Washington had lived. In 1800 the mansion was purchased by the University of Pennsylvania. About 1829 it was demolished, and replaced by twin buildings which were used by the University until it moved to West Philadelphia in the 1870's. The Alms House and House of Employment, shown in detail in Plate 25, can be seen in the distance.

PHOTOGRAPHS

A United States Post Office and Federal Building has ocupied this site since 1884. The present building was completed in 1940. Early counterparts of the street vendor in the 1982 view appear in Plate 8.

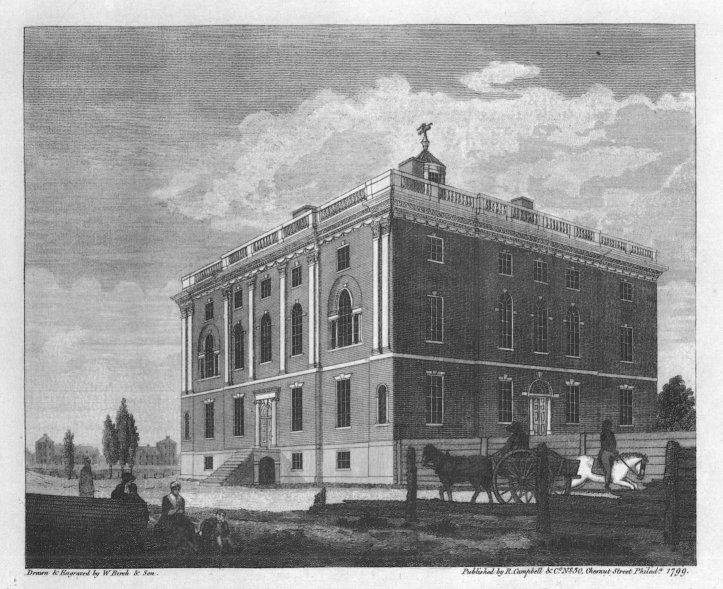

Drawn & Engraved by W. Birch & Son.

Published by R. Campbell & Co. Nº 50, Chesnut Street Philadª 1799.

THE HOUSE intended for the PRESIDENT of the *UNITED STATES*,

in *Ninth Street* PHILADELPHIA.

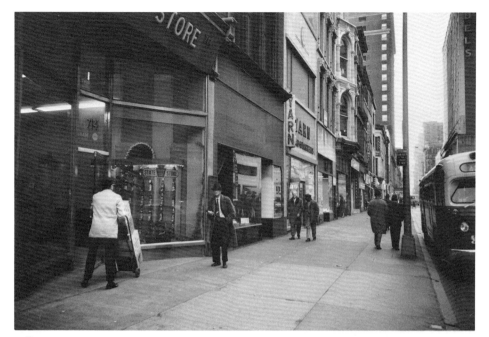

1960

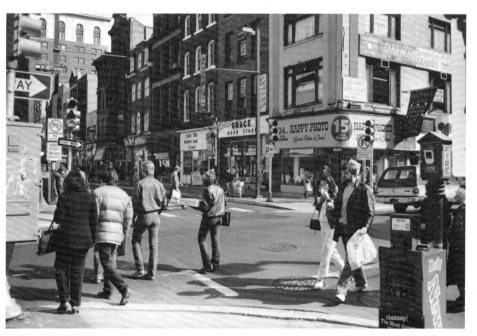

1982

PLATE 14

ENGRAVING

About 1794, when his fortunes were at their height, Robert Morris, financier of the American Revolution, purchased the entire square between Chestnut and Walnut streets from Seventh to Eighth and began building this grand marble and brick house from designs of Major Pierre Charles L'Enfant. Before it was completed his land speculations brought him to ruin. At the time of this print Morris was in debtors' prison. Not saleable, the unfinished house was demolished about 1800 and the materials sold for the benefit of his creditors.

PHOTOGRAPHS

The Chestnut Street Association has placed a tablet on Numbers 714–716 Chestnut Street to mark the site of the Morris house. The 1960 view was taken near the tablet looking west, and the 1982 view from the northwest corner of Eighth and Chestnut looking east.

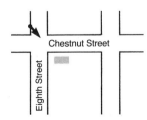

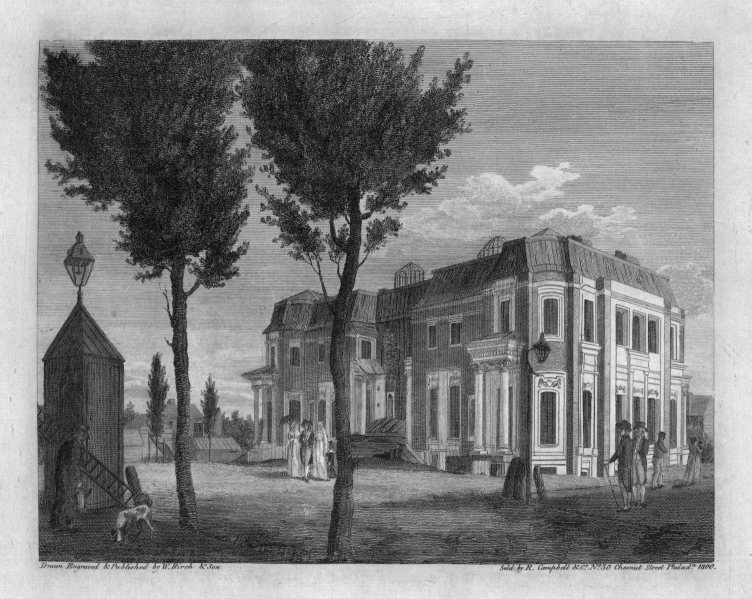

Drawn Engraved & Published by W. Birch & Son. Sold by R. Campbell & Cº. Nº 30 Chesnut Street Philadª. 1800.

An *UNFINISHED HOUSE*, in Chesnut Street **PHILADELPHIA**.

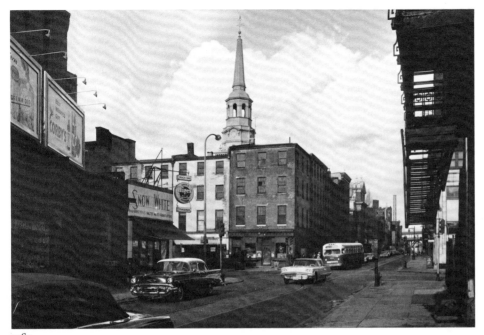

1960

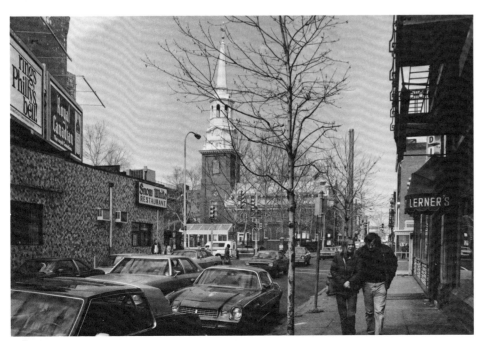

1982

PLATE 15

Christ Church was built between 1727 and 1744. The steeple was completed in 1754 and rebuilt after the 1908 fire. Both Washington and Franklin worshipped in the church. On the left, in the center of Market Street, is the Town Hall or Courthouse, built 1707–1710 and demolished in 1837. Its arcaded ground floor was the city's first permanent market. Combining a courthouse with a market continued a medieval custom.

PHOTOGRAPHS

Buildings on the northwest corner of Second and Market streets were demolished in 1963 revealing a new and striking perspective of Christ Church. The open space is part of Independence National Historical Park; the church is not.

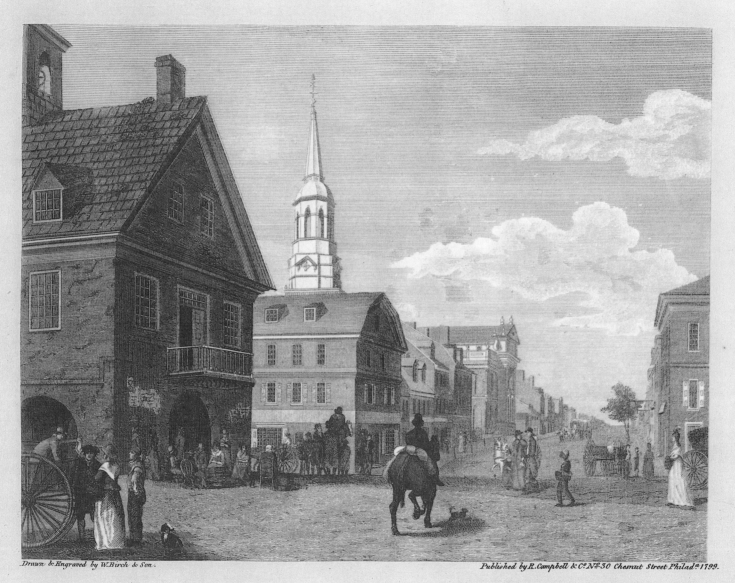

Drawn & Engraved by W.Birch & Son. Published by R.Campbell & Cº Nº 30 Chesnut Street Philadª 1799.

SECOND STREET *North from Market S.ᵗ ᵂⁱᵗʰ.* CHRIST CHURCH.

PHILADELPHIA.

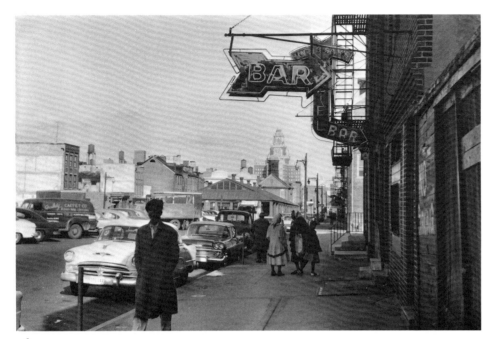

1960

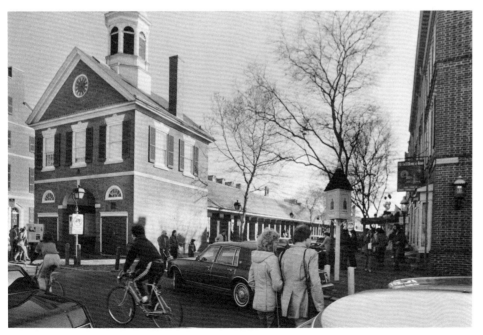

1982

PLATE 16

ENGRAVING

There were market sheds in Second Street between Pine and Cedar (now South) as early as 1745. The shed in the background is between Lombard and South. Attached to it is a fire engine house (head house) with a cupola containing an alarm bell. Before 1860 the engine house was torn down, but the shed survived until 1956. In the foreground is the shed between Pine and Lombard. A second fire engine house, known as the "Head House", was built at the northern end of that shed about 1805. That head house and the adjoining shed were restored 1962–1963.

PHOTOGRAPHS

The 1960 view was taken from a point above South Street looking north; the 1982 view from the north side of Pine Street looking south. Today the surrounding area is called New Market, and has many fine restaurants, shops and townhouses.

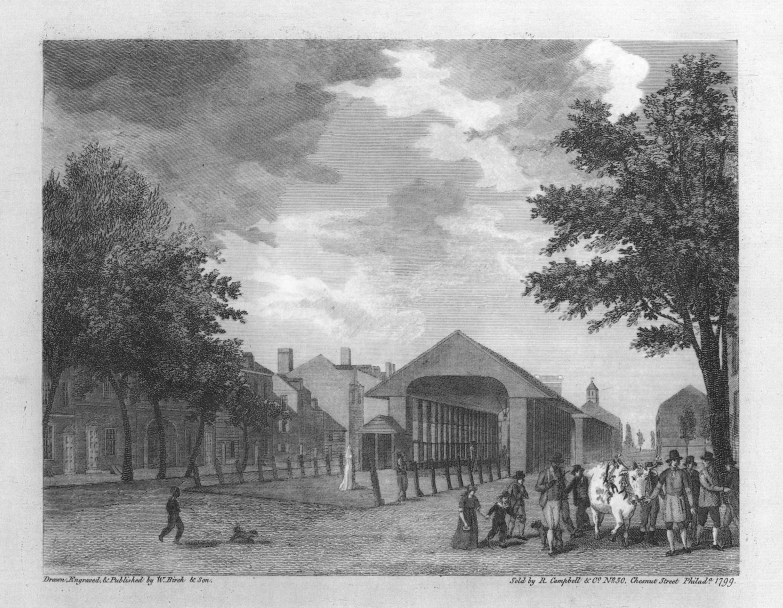

Drawn, Engraved, & Published by W. Birch & Son. Sold by R. Campbell & Cº. Nº 30. Chesnut Street Philadª 1799.

NEW MARKET, *in South Second Street* PHILADELPHIA.

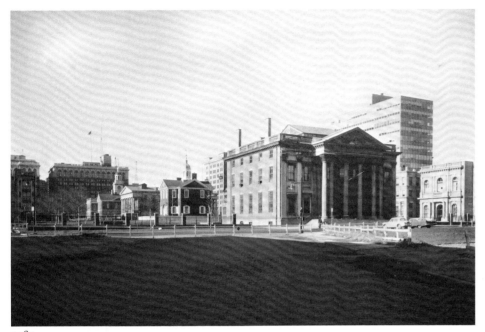

1960

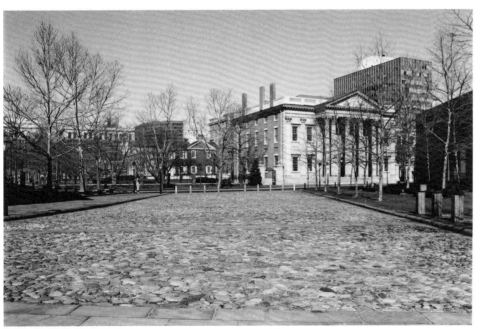

1982

PLATE 17

The Bank of the United States was created by Congress in 1791. Its building was erected 1795–1797 from designs of Samuel Blodgett, Jr. After the Bank's charter lapsed in 1811 the building was sold to Stephen Girard, who conducted his private banking business there for the next twenty years. Predecessors of the present Girard Bank used the building until 1926. In 1954 it was purchased by the Federal Government for the National Park.

PHOTOGRAPHS

The 1960 view shows a handsome alignment of buildings in the recently created Independence National Historical Park: the First Bank of the United States, Carpenters' Hall, the Second Bank (later the Old Customs House), the library of the American Philosophical Society (a reconstruction of Library Hall—Plate 19—with additions), and the steeple of Independence Hall. On the far right of the 1982 view is the Visitors' Center of the National Park.

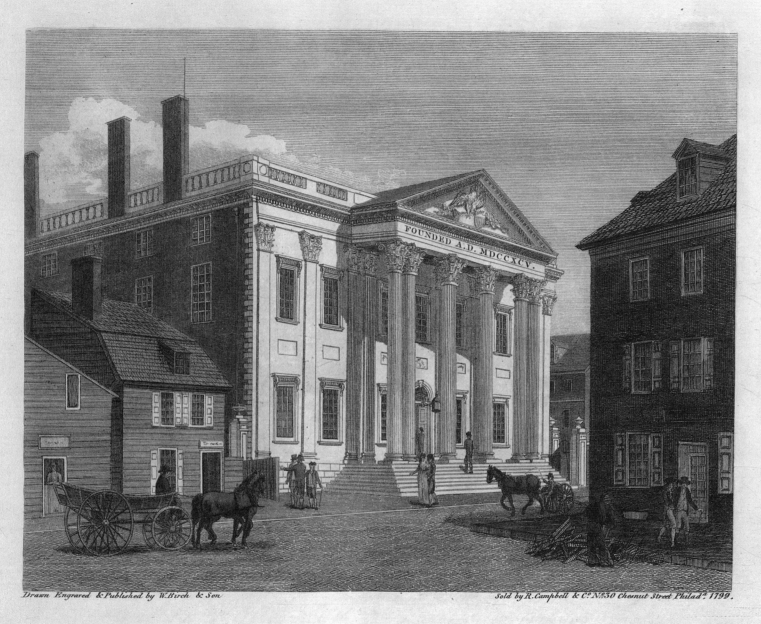

Drawn Engraved & Published by W. Birch & Son Sold by R. Campbell & Co. No. 30 Chesnut Street Philada. 1799.

BANK OF THE UNITED STATES, in Third Street PHILADELPHIA.

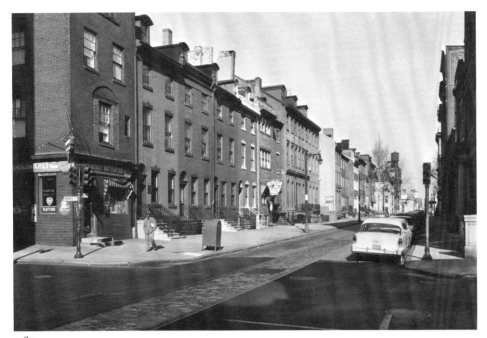

1960

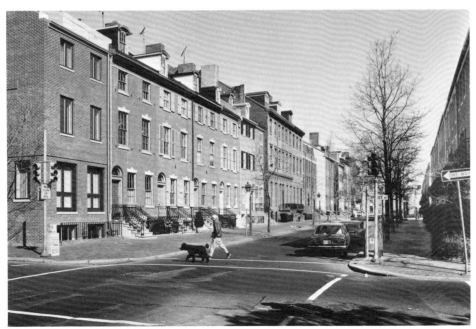

1982

PLATE 18

ENGRAVING

William Bingham, merchant, banker, and legislator, built the mansion in the foreground about 1788. In his time it was the center of social life in Philadelphia. Turned into a hotel in 1806–1807, it was badly damaged by fire in 1823, repaired, and finally demolished about 1850. The house was actually further north and west than the engraving suggests. Samuel Powel, last Mayor of the city under Penn's charter and first under the charter of 1789, owned the house to the north, now a historic house museum.

PHOTOGRAPHS

The six houses beyond the corner property on the left were built about 1815. Today they are a fine example of the restoration required since the late 1950's of owners of historically significant properties in the Society Hill area. Although cornices, dormers, doors, and windows were among the details to be restored, the most obvious change that can be seen in the pictures is the replacement of one over one by six over six windows.

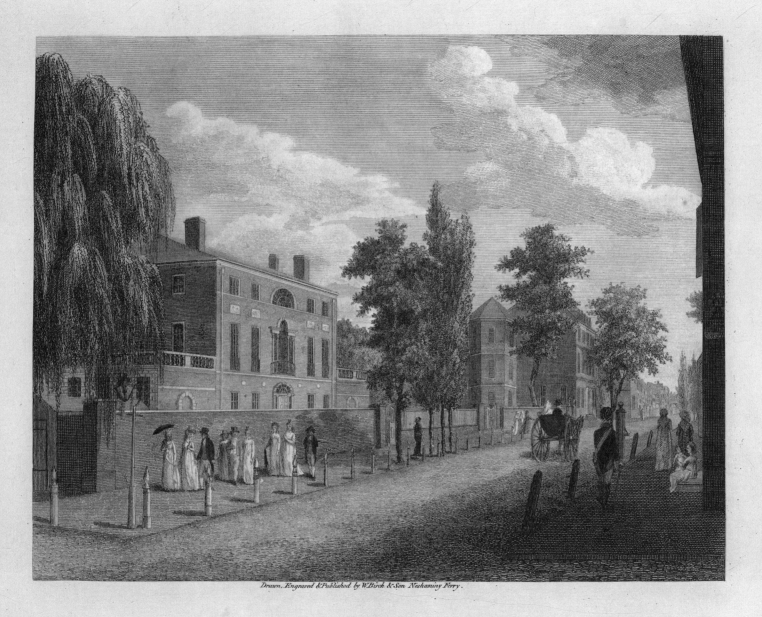

Drawn, Engraved & Published by W.Birch & Son Neshaminy Ferry.

View in THIRD STREET, *from Spruce Street* PHILADELPHIA.

PLATE 19

ENGRAVING

Founded by Benjamin Franklin and his friends in 1731, The Library Company of Philadelphia is the oldest subscription library in the country. Library Hall, home of the Company between 1790 and 1880, was built 1789–1790 from designs of Dr. William Thornton. It was demolished in 1884 in clearing a site for the ten-story Drexel Building, which was razed in 1956. Surgeons' Hall was an early building of the School of Medicine of the University of Pennsylvania.

PHOTOGRAPHS

The portion of the library of the American Philosophical Society seen in the photographs is a faithful reconstruction of Library Hall which stood on the same site. In creating Independence National Historical Park three blocks to the east of Independence Hall were cleared of all but historic buildings, the Customs House excepted, and the resulting open spaces extensively landscaped. The Park now includes forty historic buildings on forty-two acres of land.

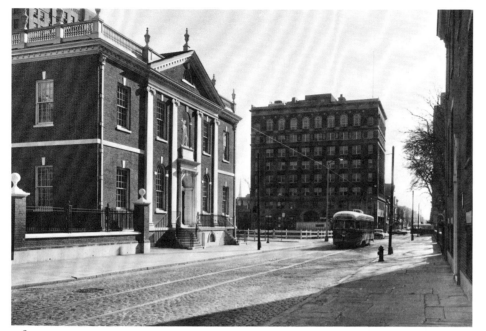

1960

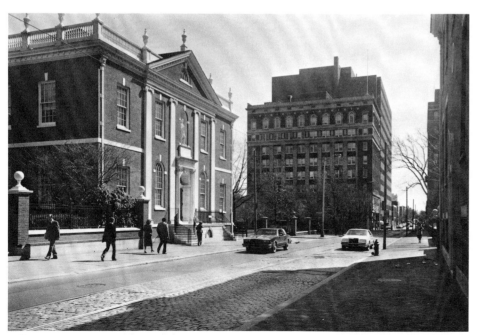

1982

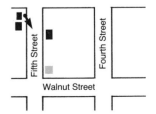

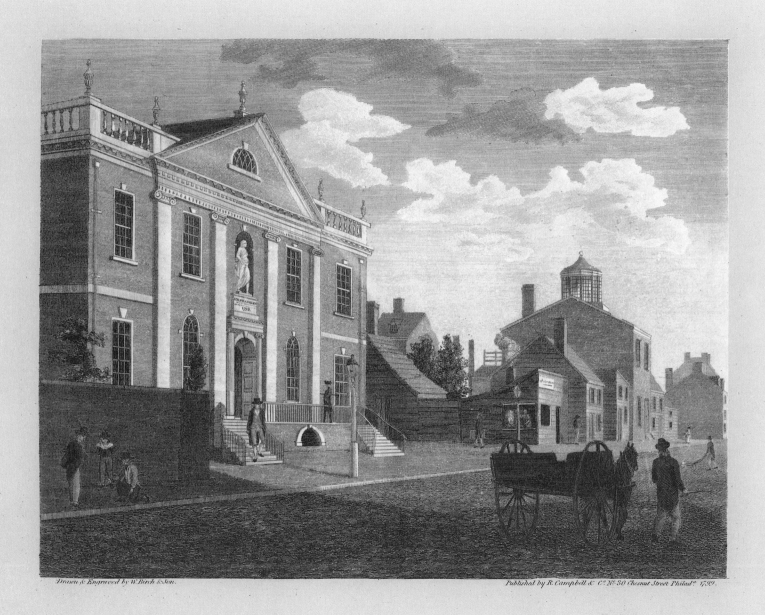

Drawn & Engraved by W. Birch & Son.

Published by R. Campbell & Cº Nº 30 Chesnut Street Philadª 1799.

LIBRARY and SURGEONS HALL, in Fifth Street PHILADELPHIA.

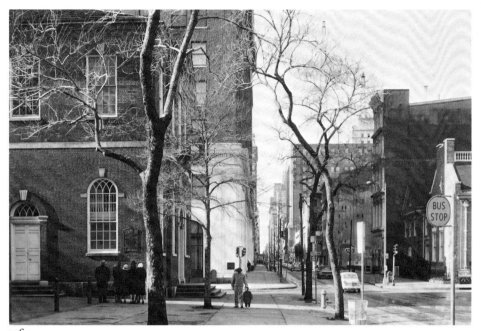

1960

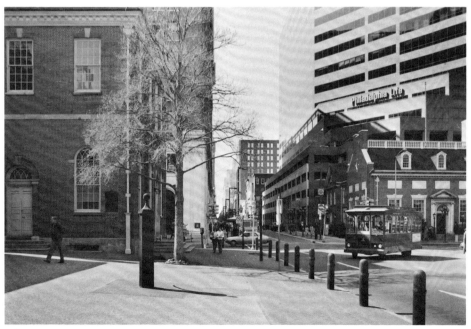

1982

PLATE 20

ENGRAVING

Congress Hall was built by the Commonwealth of Pennsylvania 1787–1789 as a county court house. It was occupied by Congress from 1790 to 1800, when Philadelphia was the nation's capital. In this building both Washington and Adams were inaugurated. During the nineteenth century it was used by municipal departments and various courts. Since 1895 it has undergone a succession of restorations and has been open to the public. The New Theatre was built 1791–1794, remodelled in 1805 from designs of Benjamin H. Latrobe, and destroyed by fire in 1820.

PHOTOGRAPHS

The two buildings on the right in the 1982 view are a branch of the First Pennsylvania Bank completed in 1951, and the Philadelphia Life Building built 1979–1980. Modelled after a nineteenth-century Fairmount Park trolley, the bus is one of a fleet introduced during the Bicentennial to carry passengers to the city's museums and historic sites.

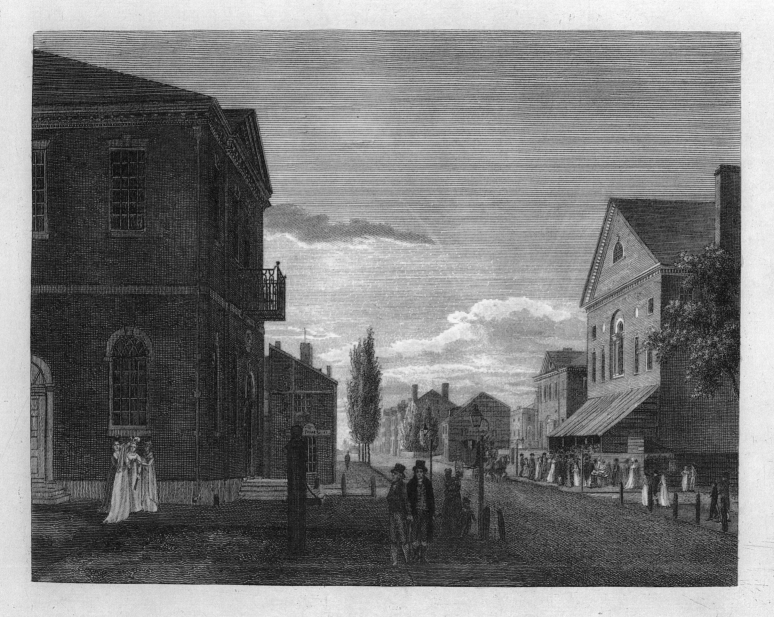

CONGRESS HALL and *NEW THEATRE,* *in Chesnut Street* **PHILADELPHIA.**

Drawn, Engraved & Published by W. Birch & Son Neshaminy Bridge. 1800.

PLATE 21

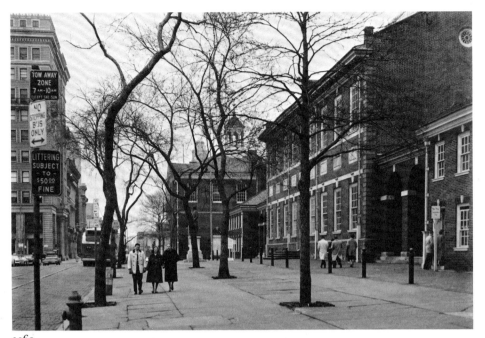

1960

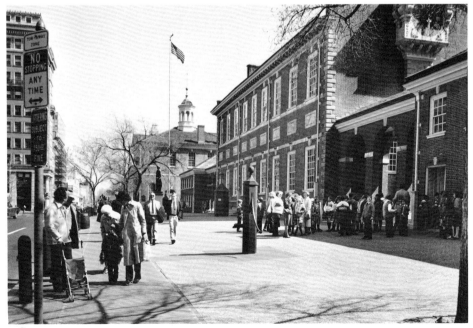

1982

ENGRAVING

The State House (Independence Hall) was built 1732–1748 by the Province of Pennsylvania from designs of Edmund Woolley. Here the Declaration of Independence was adopted by the Continental Congress, British troops quartered during the occupation of Philadelphia, and the Constitutional Convention assembled in 1787. When the Federal capital was moved to Washington in 1800 after a decade in Philadelphia the use of the building reverted to the Commonwealth, and in 1818 it was purchased by the City. The building with the cupola was built 1789–1791 as Philadelphia's city hall, and until 1800 was used by the United States Supreme Court.

PHOTOGRAPHS

In 1951 the custody and operation of the Independence Hall group of buildings and the square were transferred from the City to the National Park Service. Since 1960 the watchboxes (guardhouses) and the pumps seen in the engraving have been reconstructed.

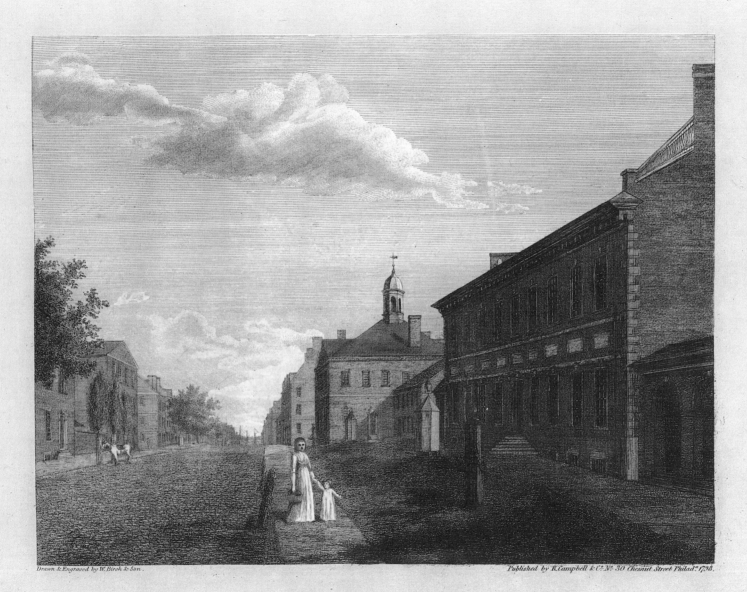

Drawn & Engraved by W. Birch & Son.

Published by R. Campbell & Cº. Nº. 30 Chesnut Street Philadª. 1798.

STATE-HOUSE,

With a View of Chesnut Street PHILADELPHIA.

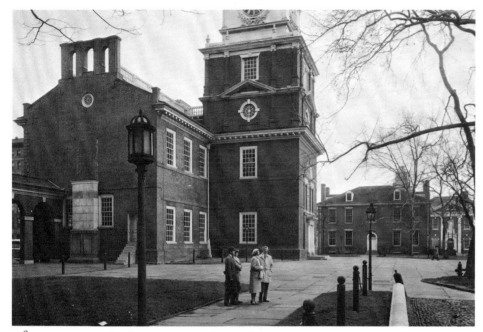

1960

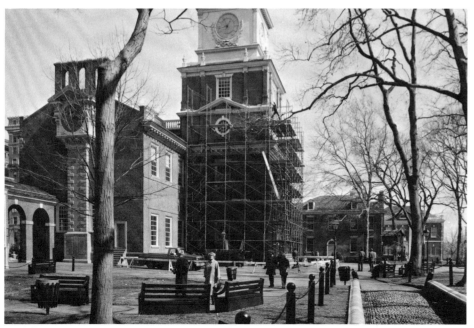

1982

PLATE 22

ENGRAVING

Between 1750 and 1753 a tower with a wooden steeple was added to the State House (Independence Hall), as was the clock by Thomas Stretch. Having deteriorated, the steeple was removed in 1781 and replaced by a hip roof with a finial. The present steeple, designed by William Strickland, was erected in 1828. To the right is Philosophical Hall, built 1786–1789 by the American Philosophical Society, the country's oldest learned and scientific society. Peale's Museum, a portrait gallery and museum of natural history, was housed in Philosophical Hall from 1794 to 1811. Library Hall is in the distance.

PHOTOGRAPHS

Independence Hall has undergone extensive restoration based on detailed research begun in 1951. The most obvious exterior change is the rebuilding of the clock which replaced the remains of the 1896–1898 reconstruction seen in the 1960 view. In the 1982 view a scaffold is being erected in preparation for periodic maintenance.

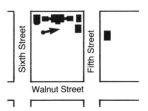

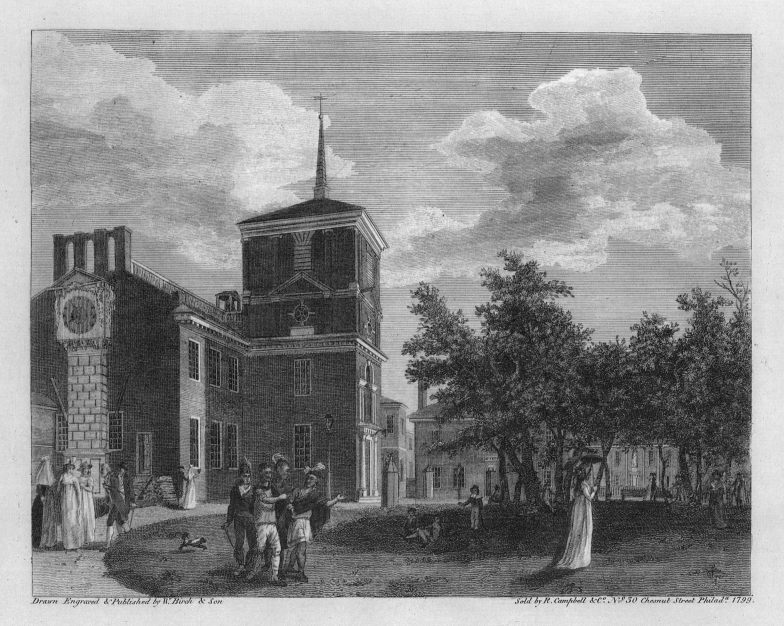

Drawn Engraved & Published by W. Birch & Son Sold by R. Campbell &Cᵒ. Nᵒ 30 Chesnut Street Philadᵃ. 1799.

BACK of the STATE HOUSE, PHILADELPHIA.

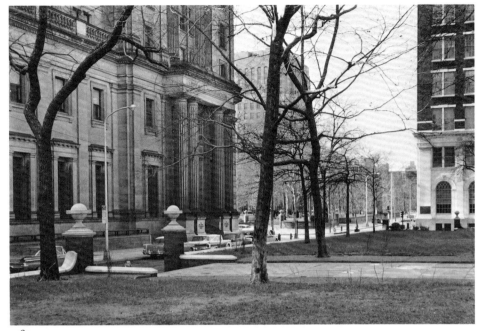

1960

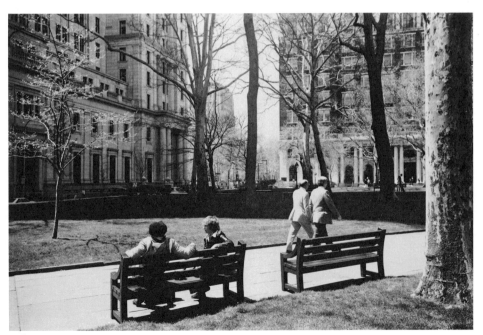

1982

PLATE 23

ENGRAVING

By 1769 all the land now called Independence Square had been acquired by the Province of Pennsylvania. During the following year the garden was enclosed by a wall seven feet high, pierced at the center of the Walnut Street side by the tall arched gateway with solid wooden doors shown in the engraving. From a platform in the Square the Declaration of Independence was read publicly for the first time on July 8, 1776, by Colonel John Nixon. Landscaping of the garden in a naturalistic style was begun about 1784 under the direction of Samuel Vaughan. It is to be redone in the same style.

PHOTOGRAPHS

The present brick retaining wall with pillared entrances and ornamental trim was built in 1915. In the distance is Washington Square, one of five reserved by William Penn for public use.

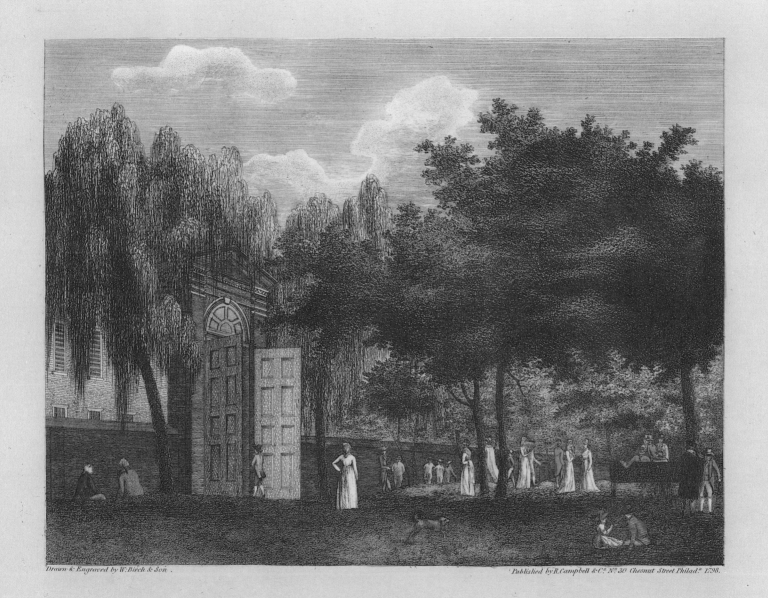

Drawn & Engraved by W. Birch & Son.

Published by R. Campbell & Cº. Nº 30 Chesnut Street Philadª. 1798.

STATE-HOUSE GARDEN, PHILADELPHIA.

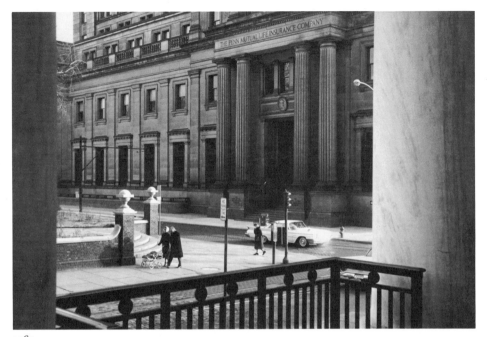

1960

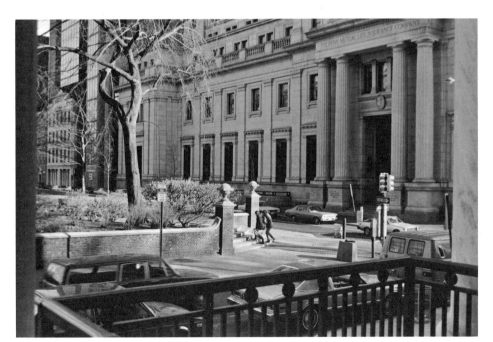

1982

PLATE 24

The Walnut Street Jail was built 1773–1776 from designs of Robert Smith and demolished about 1835. During the British occupation of the city it was used as a military prison. In the 1790's liberal policies of the managers enabled inmates to earn wages for work performed in the prison's shops, such as sawing and polishing marble, shoemaking, carding of wool for hatters, and nail making. America's first balloon ascension was made from the yard of the jail in 1784.

PHOTOGRAPHS

The views were taken from the portico of the Curtis Building and show the Penn Mutual Life Insurance building. In 1974–1975 the Insurance Company built an adjoining tower with an observation area open to the public from which there is a fine view of the port and old sections of the city. The tower was designed to incorporate, in its original place, the Egyptian revival façade of the Pennsylvania Fire Insurance Company's nineteenth-century building.

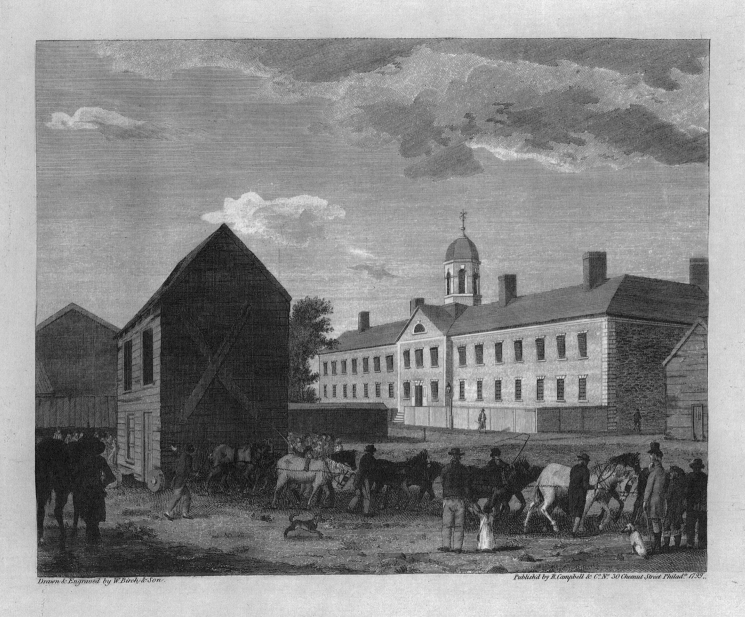

Drawn & Engraved by W.Birch & Son. Publish'd by R.Campbell & Co. No. 30 Chesnut Street Philad.a 1799.

GOAL, in *Walnut Street* PHILADELPHIA.

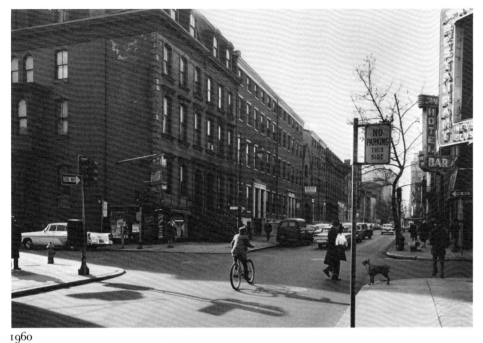

1960

PLATE 25

ENGRAVING

The Alms House is on the left and the House of Employment on the right. Both were built 1760–1767 and demolished 1834–1835, following completion of the new Alms House in Blockley Township, now part of West Philadelphia.

PHOTOGRAPHS

Little change has occurred in the block. The 1960 view was taken from the northeast corner of Tenth and Spruce streets looking west, and the 1982 view from the northwest corner of Eleventh and Spruce looking east.

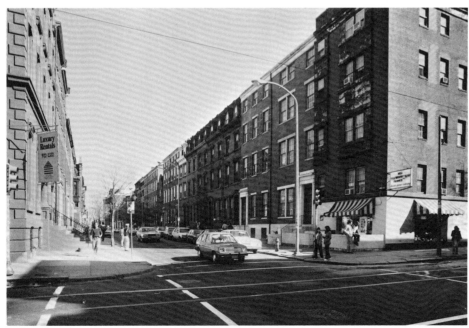

1982

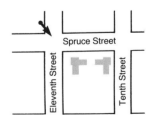

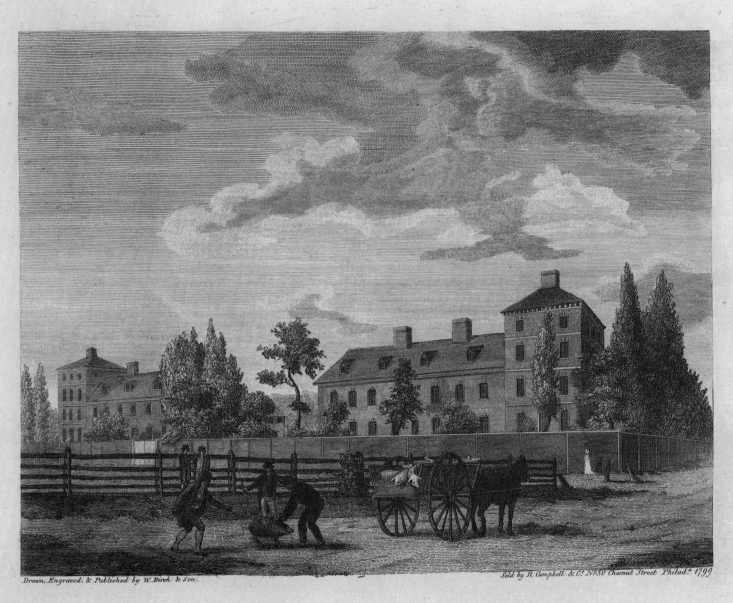

Drawn, Engraved, & Published by W. Birch & Son.

Sold by R. Campbell & C.º N.º 30 Chesnut Street Philad.ª 1799

ALMS HOUSE in *Spruce Street* PHILADELPHIA.

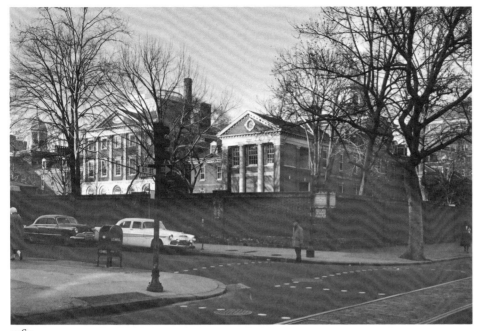

1960

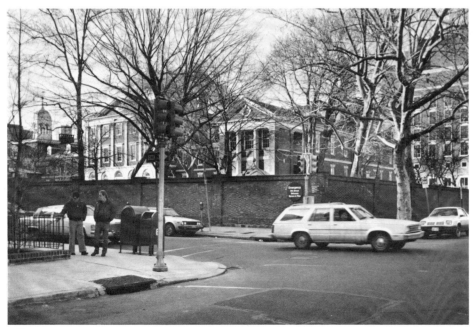

1982

PLATE 26

ENGRAVING

Pennsylvania Hospital, founded in 1751 through the joint efforts of Dr. Thomas Bond and Benjamin Franklin, was the nation's first hospital. The east wing was built about 1755 from designs of Samuel Rhoads, the west wing about 1796, and the central section 1794–1805 from designs of David Evans, Jr. Among the prominent physicians who served the hospital during the eighteenth century were William Shippen, John Morgan, Benjamin Rush, and Philip Syng Physick. Franklin, who was for a time President of the Board of Managers, left the Hospital his uncollected business debts.

PHOTOGRAPHS

Since 1960 three new buildings have been constructed in the original block occupied by the Hospital. One appears at the right in the 1982 view. These and the older structures will be connected by a "core building" now under construction. From the first, Pennsylvania Hospital has been a force in making Philadelphia an important center of medical services, education, and research.

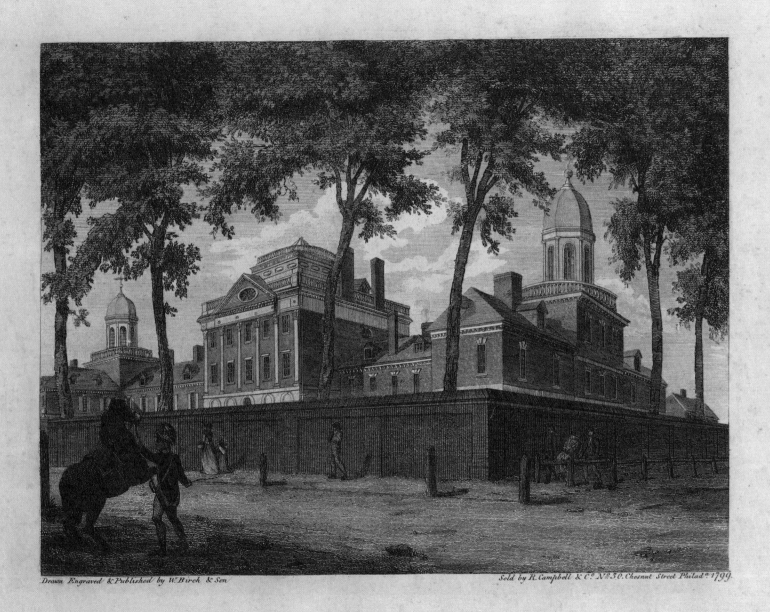

Drawn Engraved & Published by W. Birch & Son. Sold by R. Campbell & Co. No 30. Chesnut Street Philadelphia 1799.

PENNSYLVANIA HOSPITAL, in Pine Street PHILADELPHIA.

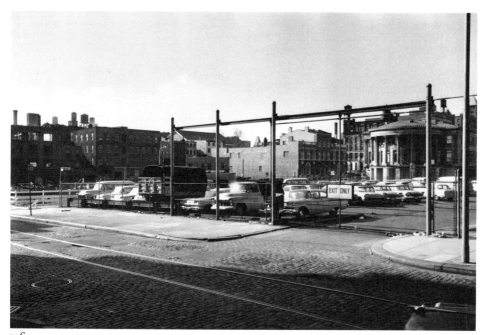

1960

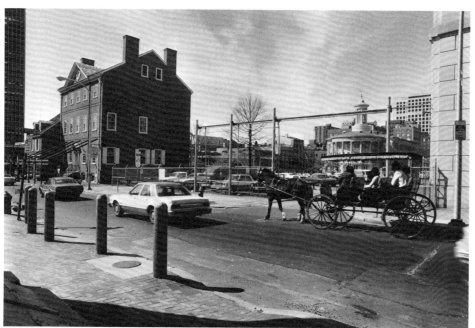

1982

PLATE 27

ENGRAVING

The Bank of Pennsylvania was built 1798–1801 from designs of Benjamin H. Latrobe and demolished 1867. City Tavern, south of the Bank, was built by subscription in 1773, torn down in 1854–1855, and reconstructed by the National Park Service in 1975–1976. During the last quarter of the eighteenth century it was the scene of many important political and social gatherings.

PHOTOGRAPHS

The building with the semicircular portico which appears in both views is the Philadelphia (Merchants') Exchange built 1832–1834 from designs of William Strickland. Its cupola was reconstructed in 1965. On the far left in the 1982 view is a corner of one of the three Society Hill Towers, to the right of the Exchange the east side of the Penn Mutual Tower, and in the foreground a carriage similar to others that are available for sightseeing in the "Olde City."

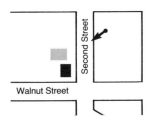

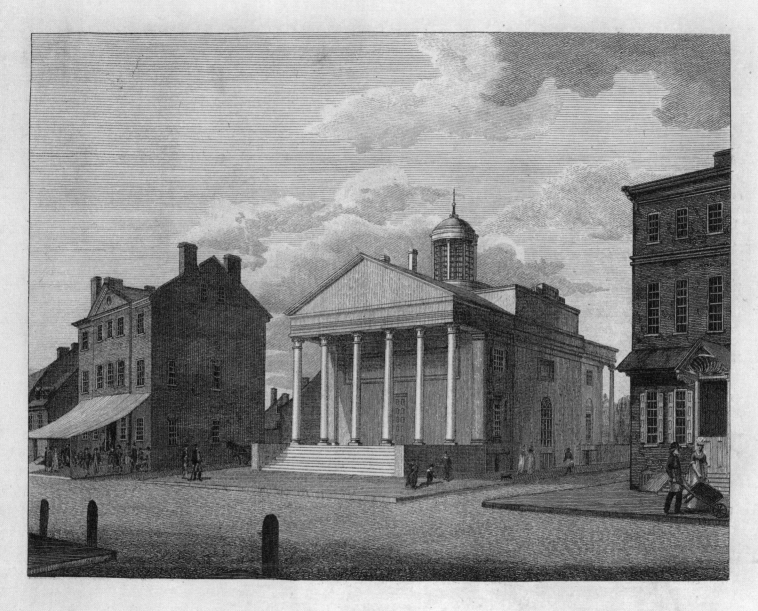

BANK OF PENNSYLVANIA, *South Second Street* PHILADELPHIA.

Drawn Engraved & Published by W. Birch & Son Neshaminy Bridge.

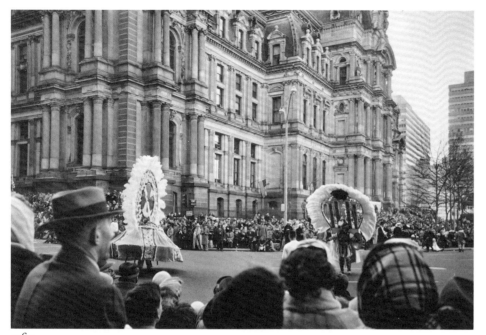

1960

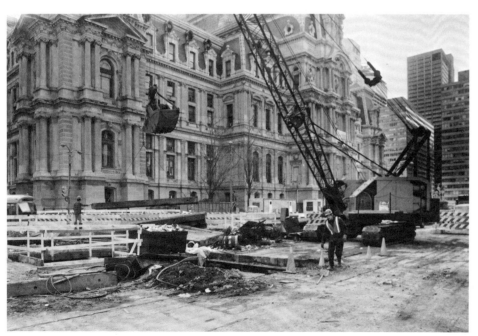

1982

PLATE 28

ENGRAVING

The Water Works or Pump House was built 1799–1800 from designs of Benjamin H. Latrobe, used until 1815 and demolished 1827–1828. With the aid of a series of pumps water from the Schuylkill River was delivered to tanks in the upper story of the Pump House and then through wooden pipes to subscribers and hydrants in various parts of the city.

PHOTOGRAPHS

Philadelphia's City Hall was built 1871–1881 from designs of John McArthur, Jr., assisted by Thomas U. Walter. On its completion it was the largest structure in the United States. Alexander Milne Calder supervised the sculpture and executed the thirty-seven foot statue of William Penn put in place on the tower in 1894. The 1960 view was taken during the Mummers' Parade, an annual New Year's frolic. In the background can be seen the earliest buildings of Penn Center built 1955–1959. The 1982 view shows work in progress on the Center City Commuter Connection Tunnel which will link rail lines that now end at Suburban Station and Reading Terminal.

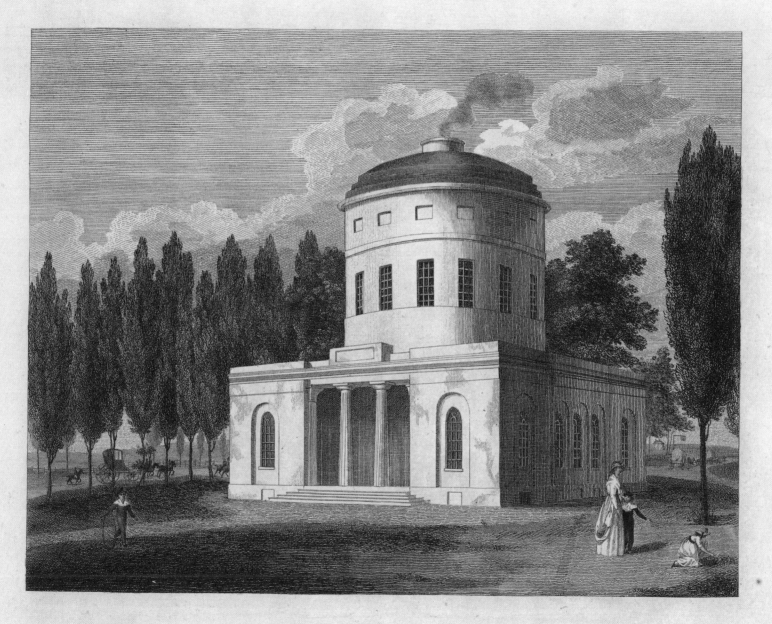

The WATER WORKS, *in Centre Square* PHILADELPHIA.

Drawn Engraved & Published by W. Birch & Son Neshaminy Bridge.

PLATE 29

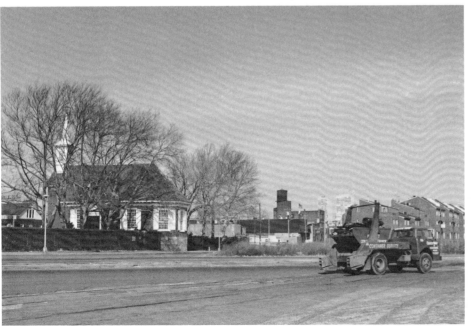

1960

1982

ENGRAVING

France, at war with Britain, had seized many neutral American merchantmen. As part of our response the frigate *Philadelphia* was built at Humphreys' shipyard in 1798–1799, largely at the expense of the citizens of the city. During the war with the Barbary pirates she ran aground in Tripoli harbor and was captured. Early in 1804 Stephen Decatur, with great daring, boarded and burned her there. The church in the background, Gloria Dei or Old Swedes', was built in 1698–1700.

PHOTOGRAPHS

Changes have occurred in the area. Townhouses have replaced some factory buildings, and Interstate Highway 95 has been constructed to the west of Old Swedes'. Piers 46 and 48 adjacent to the site of Humphreys' shipyard are to be rebuilt for the use of the Coast Guard, marine police, and fire boats. The present railroad tracks will be removed, and a new line laid in the center of Delaware Avenue.

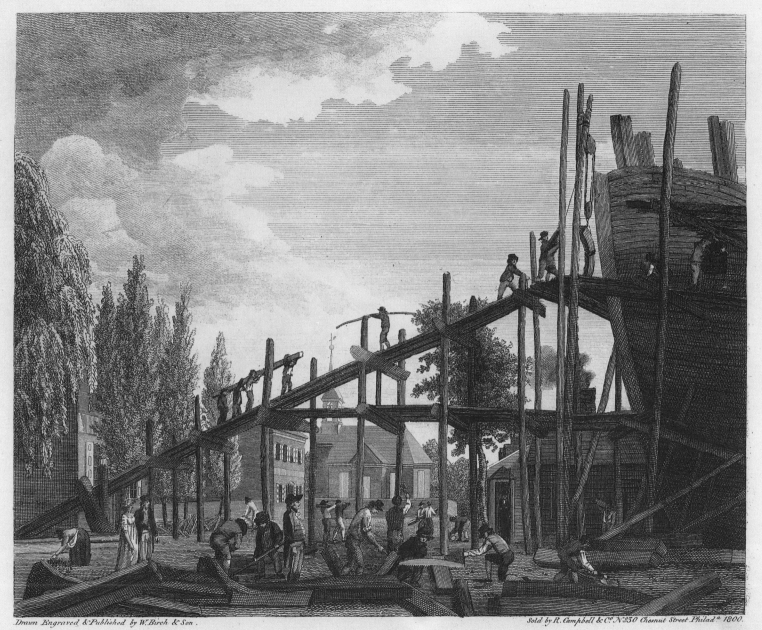

Preparation for WAR to defend Commerce.

The Swedish Church Southwark with the building of the FRIGATE PHILADELPHIA.

SUBSCRIBERS TO BIRCH'S VIEWS OF PHILADELPHIA.

Mr. James Abeen, Brunfwick, New-Jerfey	Mr. A. Eckfeldt, Philadelphia	Mr. James M'Ewin, Philadelphia	Mr. Walter Sims, on Nefhaminy, Pennfyl.
Mr. John Allen, Philadelphia	Mr. Ralph Eddowes, do.	Mr. James M'Henry, do.	Mr. John Simfon, Philadelphia
Mr. Samuel Anderfon, do.	Mr. Alexander Ewing, New-York	Mr. T. B. M'Kean, do.	Mr. Lawrence Sink, do.
Mr. Jofeph Anthony, do.	Mr. Thos. Filldfton, Duchefs County, N. Y.	Mr. Archibald Mercer, Newark, N. Jerfey	Mr. Andrew Smith, New-York
Mr. Jofiah Hewes Anthony, do.	Mr. James C. Fifher, Philadelphia	Mr. John Morriam, New-York	Mr. John Smith, Philadelphia
Mr. James Afh, do.	Mr. Richard Folwell, do.	Mrs. Merry, Philadelphia	Mr. James Smith, jun. do.
Mr. John Afhley, do.	Mr. R. R. Forbes, New-York	Mr. Peter Miercken, do.	Mr. S. Smith, Baltimore
Mr. Jacob Baker, do.	Mr. Charles R. Forfter, Philadelphia	T. Mifflin, late Governor of Pennfylvania	Mr. Willet Smith, Philadelphia
Mr. Charles N. Banckor, do.	Mr. Samuel W. Fox, do.	Mr. William Mooney, New-York	Mr. John M. Soullier, do.
Mr. William Barker, do.	Mr. George Fox, do.	Rev. Benjamin Moore, do.	Mr. John Stevens, New-York
Mr. Peter Blight, do.	Mr. Thomas W. Francis, do.	Meffrs. Morgan & Douglafs, Philadelphia	Mr. Eb. Stevens, do.
Mr. Jofeph Bolding, on Nefhaminy, Pennf.	Mr. Samuel Gattiff, do.	Mr. R. H. Morris, do.	Mr. G. G. Stuart, Germantown
Mr. P. Bond, Britifh Conful	Mr. Samuel Gibbs, near Briftol, Pennfyl.	Mr. Mofes L. Mofes, New-York	Mr. Jofhua Suteleff, Philadelphia
Mr. I. B. Bond, Philadelphia	Mr. James Gibfon, Philadelphia	Mr. Samuel Murgatroyd, Philadelphia	Mr. James Thackara, do.
Mr. J. B. Bordley, do.	Mr. Aquila Giles, New-York	Mr. Jofeph Mufgrove, do.	Mrs. R. Thomee, do.
Dr. Samuel Borrowe, New-York	Mr. Robert E. Griffith, Philadelphia	Mr. George Newman, do.	Mr. Daniel N. Train, New-York
Mr. Francis Bourgeois, Philadelphia	Mr. Archabald Gracy, New-York	Mr. William Nichols, do.	Mr. I. C. Vandenbeurel, do.
Mr. Francis Breuil, do.	Mr. J. Guillemard, Britifh Commiffioner	Mr. Jofeph Norris, do.	Mr. James Vanuxem, Philadelphia
Dr. Jofeph Brown, New-York	Mr. W. Hamilton, Wood-Lands, near Phil.	Meffrs. Nottnagel & Montmollin, do.	Mr. Ambrofe Vaffe, do.
Mr. E. Brufh, do.	Mr. Pattifon Hartfhorn, Philadelphia	Mr. Jeffe Oat, do.	Mr. Richard Varick, Mayor of New-York
Mr. John Buchanan, do.	Mr. E. Hafkell, South-Carolina	Mr. N. Olcott, New-York, for Theodore	Mr. Jofeph Viar, Spanifh Conful
Mr. Mathew Carey, Philadelphia	Mr. Ebenezer Hazard, Philadelphia	Fowler, Eaft-Chefter	Mr. Henry Voigt, Philadelphia
Mr. Lynde Catlin, New-York	Mr. William Henderfon, New-York	Mr. Stephen Page, on Nefhaminy, Pennfyl.	Mr. I. G. Wachfmuth, do.
Mr. Theophile Cazenow, Philadelphia	Mr. Jofiah Higbee, Philadelphia	Mr. Matthew Pearee, Philadelphia	Mr. Philip Wager, of Philadelphia, 2 fets, one
Mrs. S. Chaudron, 2 fets do.	Mr. Jofeph Horn, New-York	Mr. Edward Penington, do.	for himfelf, and one for Mr. Adam Reigart,
Mr. John Clifford, do.	Mr. Francis Ingraham, Philadelphia	Mr. William Prieftman, do.	of Lancafter
Mr. William Clifston, jun. do.	Mr. James Irvine, do.	Mr. Matthew Randall, do.	Mr. Onflow Wakeford, Philadelphia
Mr. William Cobbett, do.	Thomas Jefferson, Vice-Prefident of U. States	Mr. William Rawle, do.	Mr. Alexander Walker, do.
Mr. Anthony Cofte, do.	Mr. David Kennedy, Philadelphia	Mr. Robert T. Rawle, do.	Mr. George Walker, do.
Mr. J. Coulon, on Nefhaminy, Pennfylvania	Mr. John Kaighn, do.	Meffrs. George Roffier & Roulet, N. York	Mr. Robert Waln, do.
Mr. John R. Cozine, New-York	Mr. Abner Kintzing, jun. do.	Mr. C. F. Rouffet, Philadelphia	Mr. Peter P. Walter, do.
Mr. L. Croufillat, Philadelphia	Mr. B. Henry Latrobe, Richmond, Virginia	Mr. Richard Rundle, do.	Mr. Jeremiah Warder, do.
Mr. J. N. Cumming, Newark, New-Jerfey	Mr. J. W. Lawrence, New-York	Mr. John Rutherfurd, New-Jerfey	Mr. Thomas Wignell, do.
Mr. George Davis, Philadelphia	Mr. Mofes Levy, Philadelphia	Mr. William Sanfom, Philadelphia	Mr. David Williamfon, New-York
Mr. John Davis, do.	Mr. Mordecai Lewis, do.	Mr. E. Savage, do.	Mr. Martin S. Wilkins, do.
Mr. Robert Denifon, jun. do.	Mr. Robert Lifton, Britifh Minifter	Mr. Thomas W. Sattuthwaite, New-York	Mr. I. Wilfon, Philadelphia
Mr. Afbury Dickins, do.	Mr. William Lynch, Philadelphia	Mr. William Sergeant, Philadelphia	Mr. I. Winter, New-York
Mr. George Dobfon, do.	Mr. Jofeph Lyon, jun. Elizabeth-town, N. J.	Mr. James Seton, New-York	The Chevalier d'Yrujo, Spanifh minifter
Mr. Edward Duffield, Benfield, Pennfylvania	Mr. William M'Pherfon, Philadelphia	Dr. William Shippen, Philadelphia	
Mr. W. T. Dunderdale, New-York	Rev. Samuel Magaw, do.	Mr. Paul Siemen, do.	

☞ An additional Lift of Subfcribers will be added to the next Edition of this Page.

The Publifher of this Work informs thofe Ladies and Gentlemen who wifh to be poffeffed of the Philadelphia Views, that, by fending a line directed to William Birch, at Springland-Cot, near Nefhaminy-Bridge, on the Briftol road, Pennfylvania, fhall be fupplied, to whatever place they may direct. The price of the Work, in boards, is 28 Dollars; bound, 31 dollars; if coloured, in boards, $41\frac{1}{2}$ Dollars; bound, $44\frac{1}{2}$ Dollars. Alfo may be had, a large Print of the Frontifpiece, $25\frac{1}{4}$ inches by $21\frac{1}{2}$ engraved in an elegant and bold ftyle, for the purpofe of framing: Price 6 Dollars plain, and 9 coloured. A companion to which is now engraving, to be the City of New-York, which will, together, compofe an elegant pair of Prints of the two principal Cities of North-America.

A SELECTION OF RELATED PICTURES: AN APPENDIX

MANY OF THE SITES AND BUILDINGS pictured by Birch in 1800 have been the subject of views by others. The most significant are reproduced as illustrations in the seven readily available books listed below and are cited under the appropriate Birch plate number in the list of related pictures that follows.

REFERENCES

APS *Historic Philadelphia*. Philadelphia, American Philosophical Society, 1953. (Transactions, Vol. 43, Part 1.)

Finkel Finkel, Kenneth. *Nineteenth-Century Photography in Philadelphia*. New York, Dover Publications, 1980.

Looney Looney, Robert F. *Old Philadelphia in Early Photographs, 1839–1914*. New York, Dover Publications, 1976.

Snyder Snyder, Martin P. *City of Independence: Views of Philadelphia before 1800*. New York, Praeger Publishers, 1975.

Tatum Tatum, George B. *Penn's Great Town*. Philadelphia, University of Pennsylvania Press, 1961.

Wainwright Wainwright, Nicholas B. *Philadelphia in the Romantic Age of Lithography*. Philadelphia, The Historical Society of Pennsylvania, 1958.

Wolf Wolf, Edwin, 2nd. *Philadelphia: Portrait of an American City*. Harrisburg, Stackpole Books, 1975.

RELATED PICTURES

PLATE 2 *City and Port.* ca. 1720 (Tatum, Ill. 10; Snyder, p. 30–31; Wolf, p. 24–25) Drawing 1752—engraved 1754 (Snyder, p. 44–45; Wolf, p. [40–41]; 1752–1778, Snyder, p. [69]) 1777 (Snyder, p. 115) ca. 1810 (Tatum, Ill. 36)

PLATE 3 *Plan of the City.* 1683 (Snyder, p. 18; Tatum, Ill. 2; Wolf, p. 35) 1762 (Snyder, p. [63]) 1776 (Snyder, p. 67) ca. 1796 (Snyder, p. [140]) 1798 (Snyder, p. [203]) 1802 (Snyder, p. [200]; Wolf, p. 125)

PLATE 4 *Arch Street Ferry.* 1831 (Wolf, p. 165) ca. 1920 (Architectural rendering, Tatum, Ill. 135) 1925 (Looking west from Camden, Wolf, p. 295)

PLATE 6 *New Lutheran Church.* 1794 (Earlier church on site, Snyder, p. 139)

PLATE 10 *High Street Market.* 1838 (APS, p. 308, Fig. 5) 1859 (Finkel, p. 69) ca. 1859 (Looney, p. 72) 1880 (Looney, p. 32) ca. 1905 (Finkel, p. 208; Looney, p. 74; Wolf, p. 258) 1907 (Wolf, p. 275)

PLATE 11 *High Street from Country Market-place.* 1798 (Earlier Birch, Snyder, p. [232], Fig. 146)

Published by The Free Library of Philadelphia on the occasion of the three hundredth
anniversary of the founding of the City. Printed in an edition of 1250 copies
on Mohawk Superfine paper. Designed by Freeman Keith, and
composed, printed and bound by The Stinehour Press
and The Meriden Gravure Company.